HOW TO DRAW VAMPIRES

PRESENTED BY BEN DUNN

ILLUM... ...DUNN

D... ...ON

D... ...ON

BRIAN DENHAM

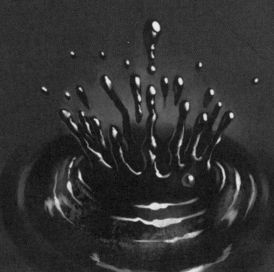

ntarctic Press Presents: How to Draw Vampires Supersize TPB #1, February 2010, is published by Antarctic Press, 7272 Wurzbach, Suite #204, San
ntonio, Texas 78240. FAX#: (210) 593-0692. Text © David Hutchison. Art © Ben Dunn and David Hutchison. All other material is ™ and © Antarctic
ress. No similarity to any actual character(s) and/or place(s) is intended, and any such similarity is entirely coincidental. Nothing from this book may be
eproduced without the express written consent of the authors, except for purposes of review or promotion. *"Silly preacher, you can't fight a rainbow!"*
rinted and bound in Canada.

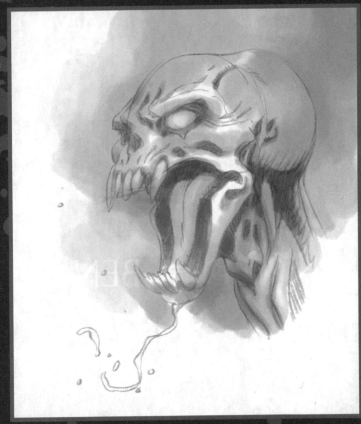

CONTENTS

INTRODUCTION

Vampires are possibly the most popular supernatural force on Earth.

Among werewolves, zombies, demons and mummies, and even fishmen, there are none that reflect both the hopes and fears of the people who follow their exploits. We fear, above all else, our own mortality. While these children of the night embody our worst fears, their strength and ageless nature continue to fascinate us.

It's no surprise, considering the rich history and iconography inherent to vampire lore. The Gothic settings and fog-shrouded streets of London that introduced us to bloodsuckers like Varney and Dracula for the first time. The bold representations of Good and Evil intertwined with Christian symbolism that have remained in the mythos to this day.

But vampires have grown far beyond the confines of a bloodthirsty creature stalking victims through shadow-haunted cemeteries. Over time, not only have they shown greater depth of character, they have often become the protagonists of our modern stories.

In this volume, we will explore some of the elements that have contributed to the vampire legend. We will cover the varying types of vampire as well as those who hunt them, how to find them and how to destroy them.

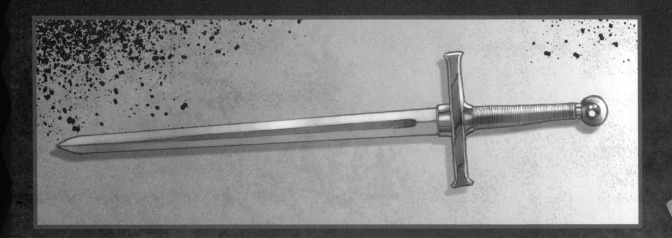

FANGS

The most obvious and telling feature of any vampire are those elongated fangs. These weapons come in any number of shapes and sizes, depending on the type of vampire you want to depict.

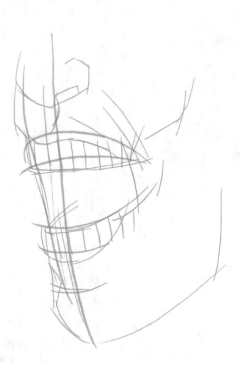

When drawing the fangs, draw the teeth as you would for a normal mouth first, adding the fangs later.

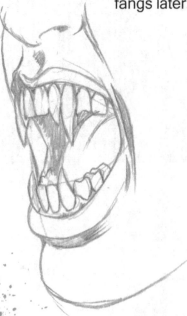
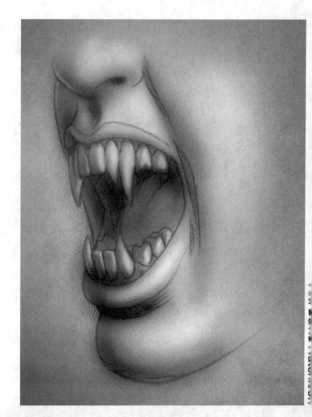

More often than not, only the canine teeth are lengthened.

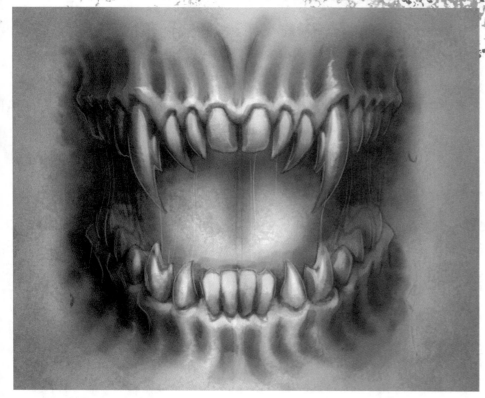

Art: David Hutchison

You may be interested in designing the fangs for your character ahead of time. You can do this by simply drawing one side of the mouth with the features you want and mirroring the sketch on a computer or a photocopy.

In some types of vampires, different teeth are enhanced. For instance, the two front teeth become sharp to mimic a rat's incisors, or the canines could be shaped to resemble those of a snake as opposed to a dog or a bat.

Some teeth may be de-emphasized to make the fangs more impressive.

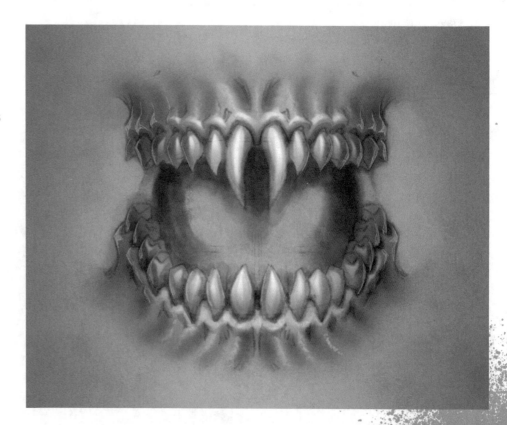

Adding blood to fangs can be difficult depending on the approach you intend to use. It's all too easy to confuse the viewer and obscure your work.

While blood is naturally dark, it's also shiny. Keep this in mind, as dark blood against the inside of the mouth can make it look like your vampire has lost all of his teeth.

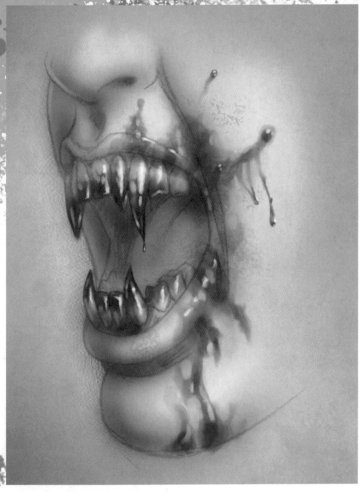

Art: David Hutchison

Take a good look at any reference images. You can get a good idea of not only how to depict blood, but how blood lands on various surfaces and what different types of blood impact look like.

By flicking a toothbrush or paint-brush onto your drawing, you can achieve some interesting effects and really get the blood flying.

Adding a little saliva to the mix can make your drawing more visceral than it would be normally.

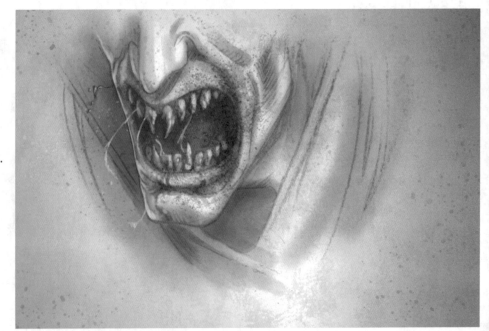

BLOOD

Art: David Hutchison

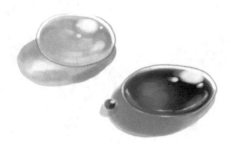

Let's talk for a minute about blood. More often than not, when we think of vampires, we think of blood. Without it, most vampires would simply dry up and blow away. There are any number of theories as to why vampires feed on blood, and they are as varied as the folklore from which the vampire originated.

Blood really is thicker than water, but it acts in many of the same ways.

The red cells in blood give it its characteristic coloring. These cells are suspended in a fluid called plasma.

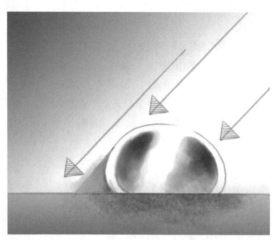

When light hits a drop of water, some of the light is reflected and some passes through the drop, as illustrated here. Blood is semi-opaque, so some light still manages to pass through the plasma in the blood.

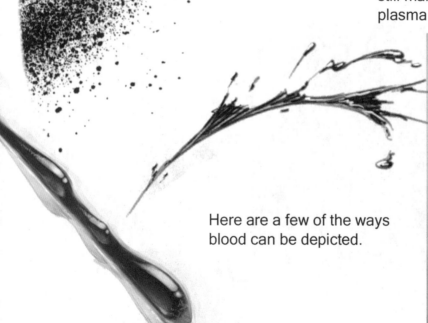

Here are a few of the ways blood can be depicted.

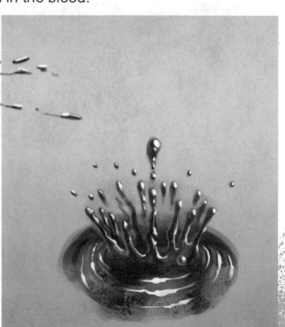

Eyes

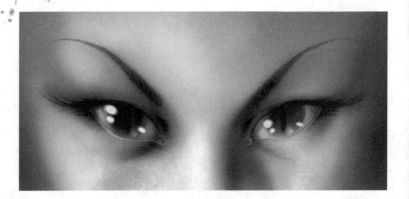

The eyes are truly the windows to the soul, making a vampire's human prey all the more vulnerable. Only the strongest personalities can resist a vampire's hypnotic gaze.

The different types of eyes you can draw are nearly limitless. You could create a kind of cat's eye, as I've done here, or perhaps some kind of glowing effect. Totally black or red are good choices as well.

In general, you'll want to keep the eyes about one eye-width apart.

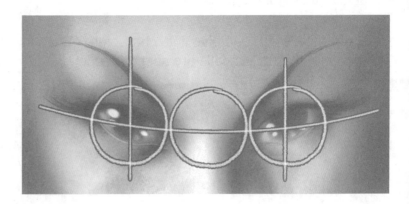

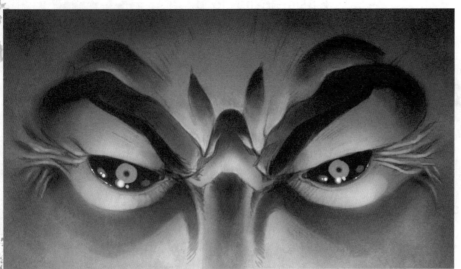

Lighting can have a huge impact on how effective a vampire's stare seems. Ramp up the dramatic lighting to better convey the supernatural force being directed at the human foolish enough to meet this gaze.

Art: David Hutchison

DRACULA

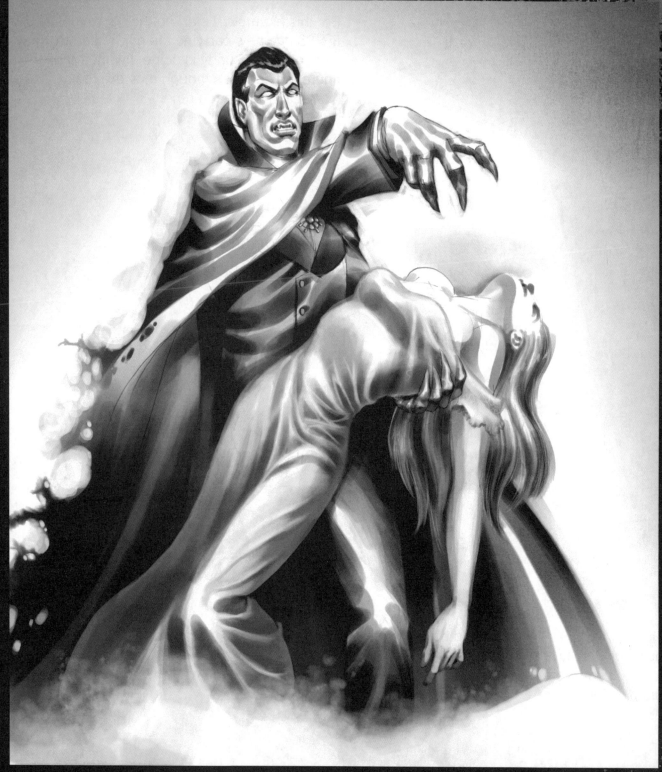

Art: David Hutchison

It's good to be the King, and Dracula is the prototype of every vampire that came after him. It's not hard to see why Bram Stoker chose to use him as the villain of his novel. The real-life Vlad Dracula's exploits are far more brutal and bloody than any fictional novel he's appeared in.

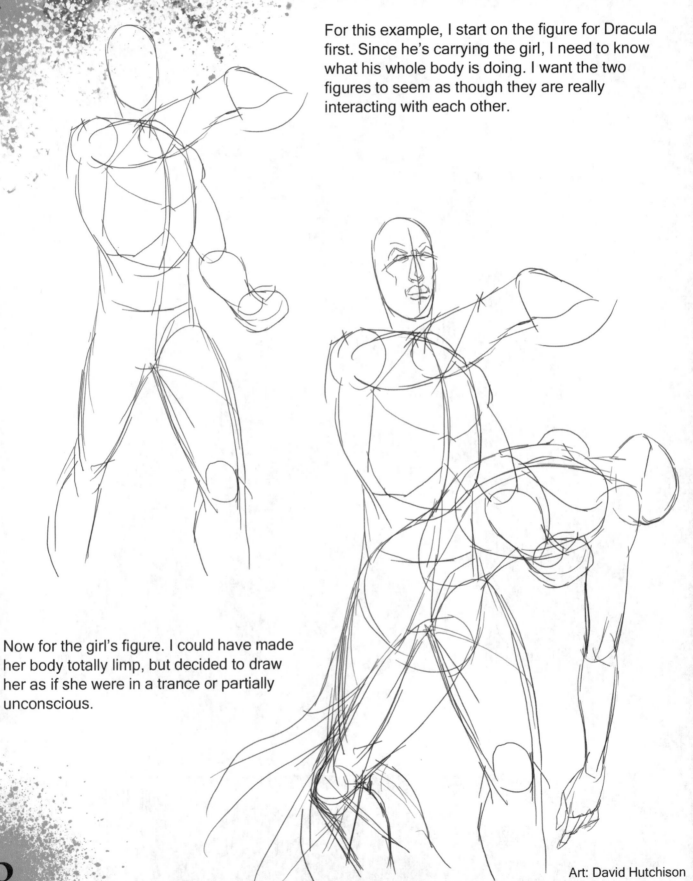

For this example, I start on the figure for Dracula first. Since he's carrying the girl, I need to know what his whole body is doing. I want the two figures to seem as though they are really interacting with each other.

Now for the girl's figure. I could have made her body totally limp, but decided to draw her as if she were in a trance or partially unconscious.

Art: David Hutchison

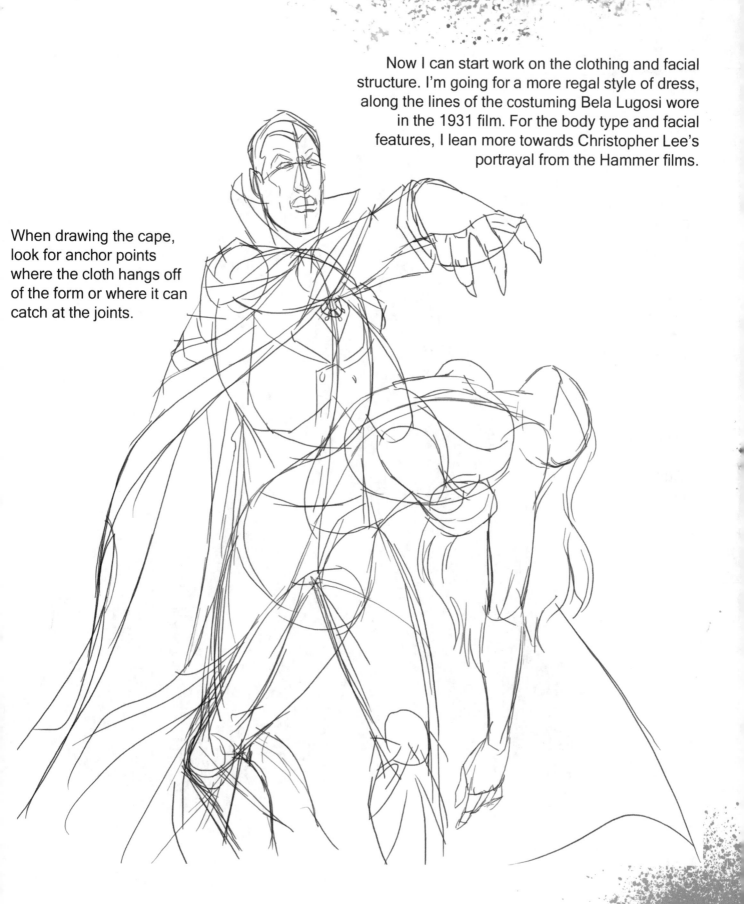

Now I can start work on the clothing and facial structure. I'm going for a more regal style of dress, along the lines of the costuming Bela Lugosi wore in the 1931 film. For the body type and facial features, I lean more towards Christopher Lee's portrayal from the Hammer films.

When drawing the cape, look for anchor points where the cloth hangs off of the form or where it can catch at the joints.

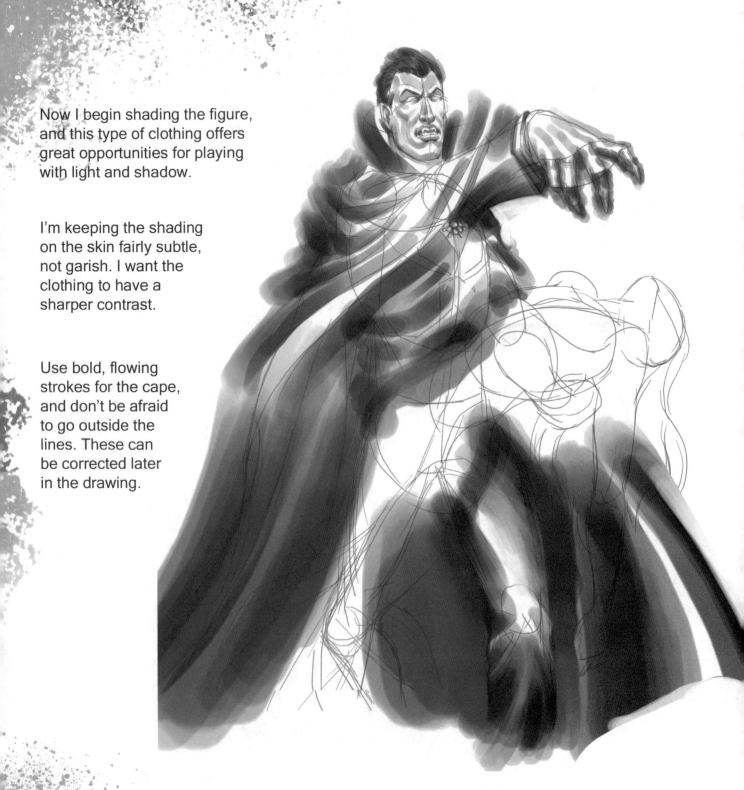

Now I begin shading the figure, and this type of clothing offers great opportunities for playing with light and shadow.

I'm keeping the shading on the skin fairly subtle, not garish. I want the clothing to have a sharper contrast.

Use bold, flowing strokes for the cape, and don't be afraid to go outside the lines. These can be corrected later in the drawing.

Now we can start on the female figure.

I made the material of the dress lighter than Dracula's clothing to make the girl's shape pop out more.

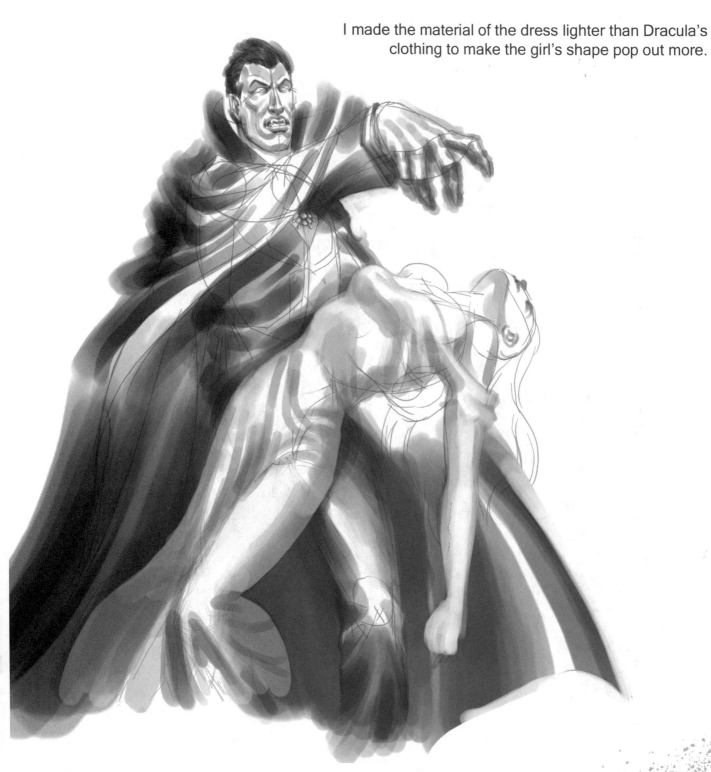

I also want the dress to seem thinner as well. Thin material tends to crease more, so I add more wrinkles to the fabric of the dress in areas where it falls on the figure.

Now for clean-up and final details.

Here I've added lace and accentuated the folds in the dress. I filled in the hair and face of the girl.

In the final steps, I've cleaned up the edges of the figure, matching the tone of the background and adding little touches where needed.

I intentionally kept the face vague, as Dracula is the focus of the piece.

Art: David Hutchison

In finishing the piece, I added Dracula's hand supporting the girl and shaded the edges of the picture to draw more attention to the main figure, as seen in the full illustration at the start of this section.

NOSFERATU

Art: Ben Dunn

The first film adaptation of Stoker's *Dracula* was the 1922 silent film *Nosferatu*. The count as depicted in the film is tall and rail-thin, with elongated fingers and a chalk-white complexion.

It is perhaps one of the most repugnant and frightening depictions of Dracula ever committed to film.

I start the drawing by concentrating on the Nosferatu's cadaverous physique. I also lay in the basic structure of his claw-like hands. Hands can add as much to a character's performance as the expression on his face.

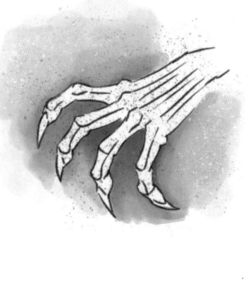

Now for the main character features! Our Nosferatu is modeled on a rat, with his two fangs and long nose right up front and his long, pointy ears.

He also looks ill. He has pale skin drawn over hollow cheeks, with large, hungry eyes.

Essentially, you need to draw a skull. It's far easier to fill in details in this case, since you don't have to account for the body fat you would find in a normal face.

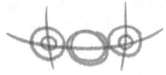

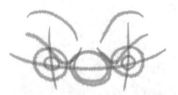

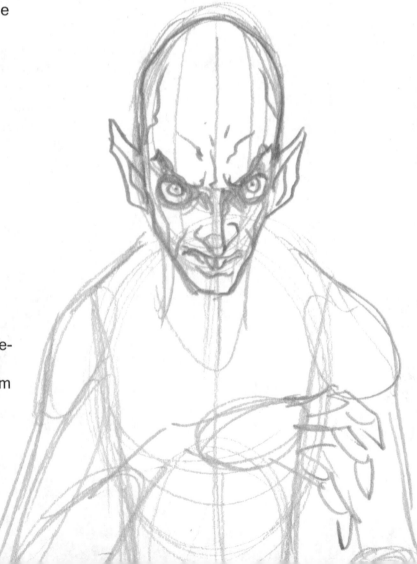

Remember to keep those eyes an eye-width apart. Because of the withered nature of the character, the eyes seem farther apart than they actually are.

The good count's clothing is almost funerary in nature.

I've added large lapels and buttons to give a slightly regal aspect to him.

His coat is extremely long, accentuating his tall, emaciated frame.

I'm not planning to add much detail to the feet and shoes. I want the viewer's eye drawn more to the head and hands, so those areas will carry most of the information in the drawing.

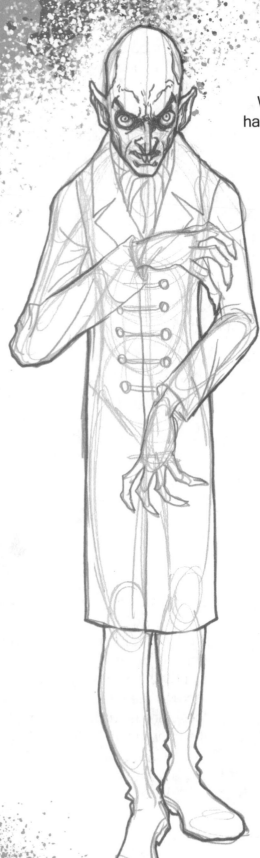

We're ready to start inking. In this case, I'm doing some hatching to the face and concentrating it around the eyes. I want him to look haggard, even desperate.

In contrast, I give his outline a smooth, flowing line. I want his clothing to be neat and well maintained.

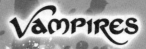

Now to add some creases to the coat sleeves and detail the neck scarf. The wrinkles in the coat are going to serve more as a guide for inking in the coat. I don't want to leave the highlighting to chance.

I'm pretty satisfied with the initial inks. I'll erase the sketch lines and work on the final inks and details.

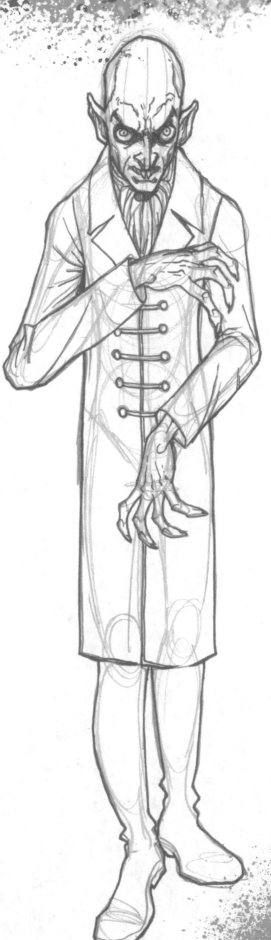

Art: Ben Dunn

Our Nosferatu character cleaned up, with full inks, background, and shading. I felt setting the time of day at dusk was evocative of the character. Interestingly, prior to the film *Nosferatu*, vampires were not affected by sunlight. There's even a scene in the *Dracula* novel in which he walks London's streets during the day.

SUCCUBUS

Art: Ben Dunn

Succubi are not vampires, but have become closely linked with them. There are plenty of similarities between the two. While succubi also feed off of the living, they consume the life energy of their victims without drinking blood. A succubus will become a companion to a man, usually a widower or elderly male.

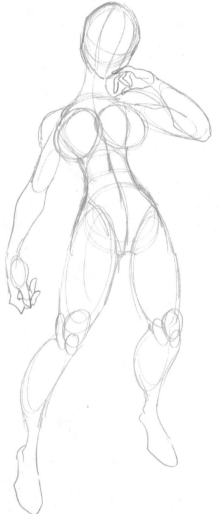

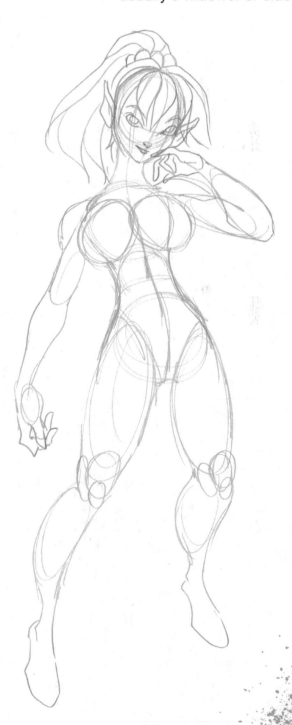

The longer the succubus is around, the weaker and weaker the man becomes, until he succumbs to her influence and dies.

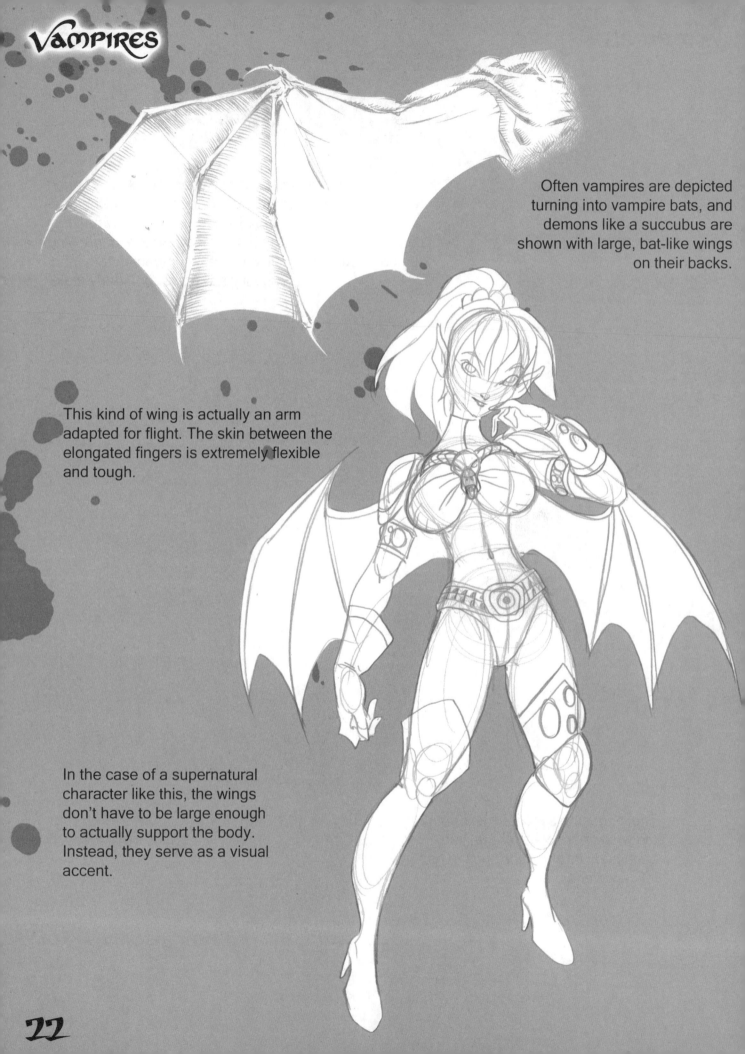

Often vampires are depicted turning into vampire bats, and demons like a succubus are shown with large, bat-like wings on their backs.

This kind of wing is actually an arm adapted for flight. The skin between the elongated fingers is extremely flexible and tough.

In the case of a supernatural character like this, the wings don't have to be large enough to actually support the body. Instead, they serve as a visual accent.

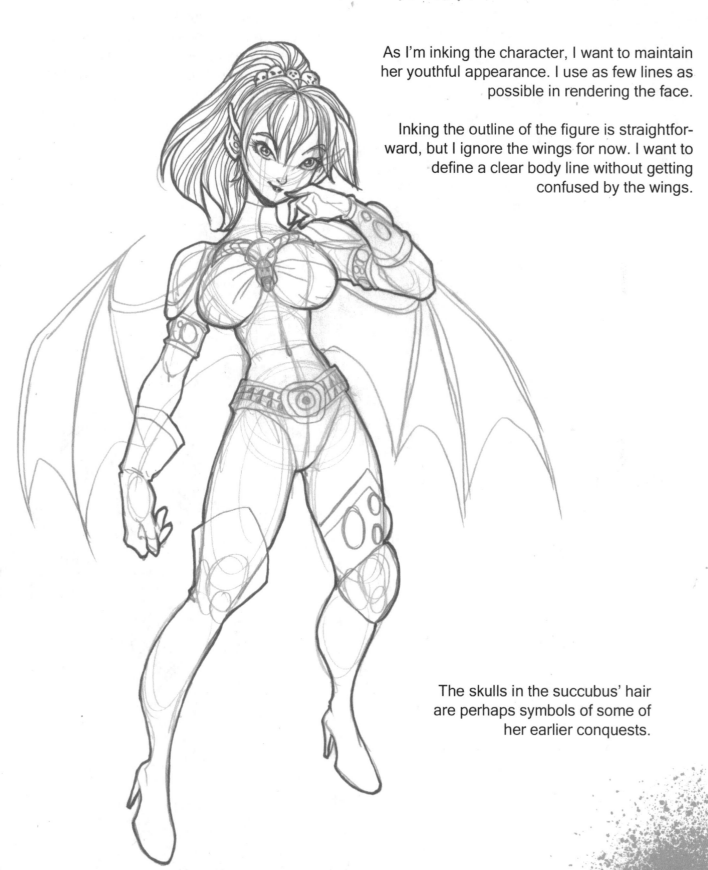

As I'm inking the character, I want to maintain her youthful appearance. I use as few lines as possible in rendering the face.

Inking the outline of the figure is straightforward, but I ignore the wings for now. I want to define a clear body line without getting confused by the wings.

The skulls in the succubus' hair are perhaps symbols of some of her earlier conquests.

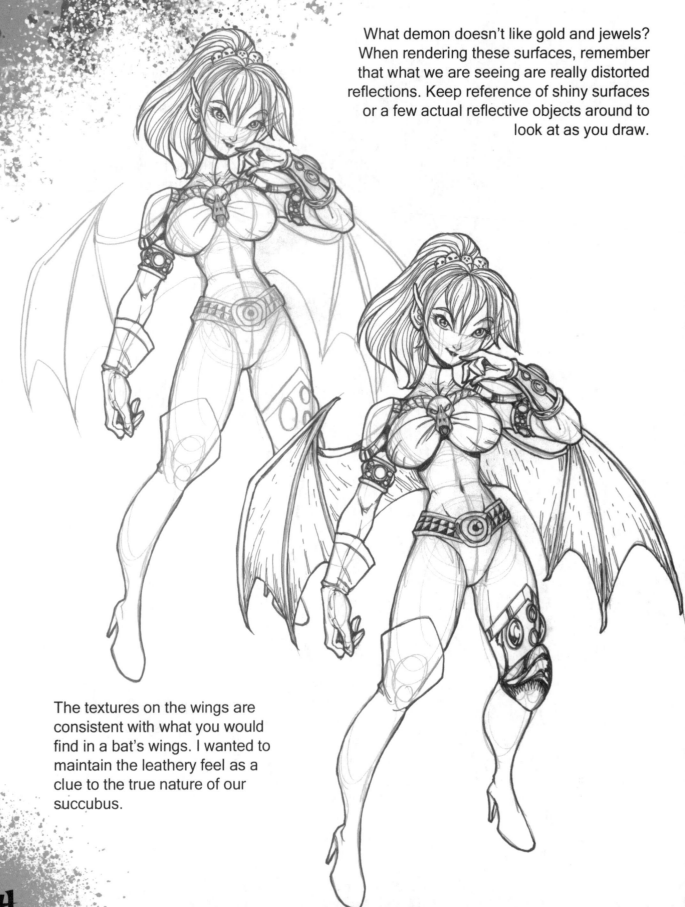

What demon doesn't like gold and jewels? When rendering these surfaces, remember that what we are seeing are really distorted reflections. Keep reference of shiny surfaces or a few actual reflective objects around to look at as you draw.

The textures on the wings are consistent with what you would find in a bat's wings. I wanted to maintain the leathery feel as a clue to the true nature of our succubus.

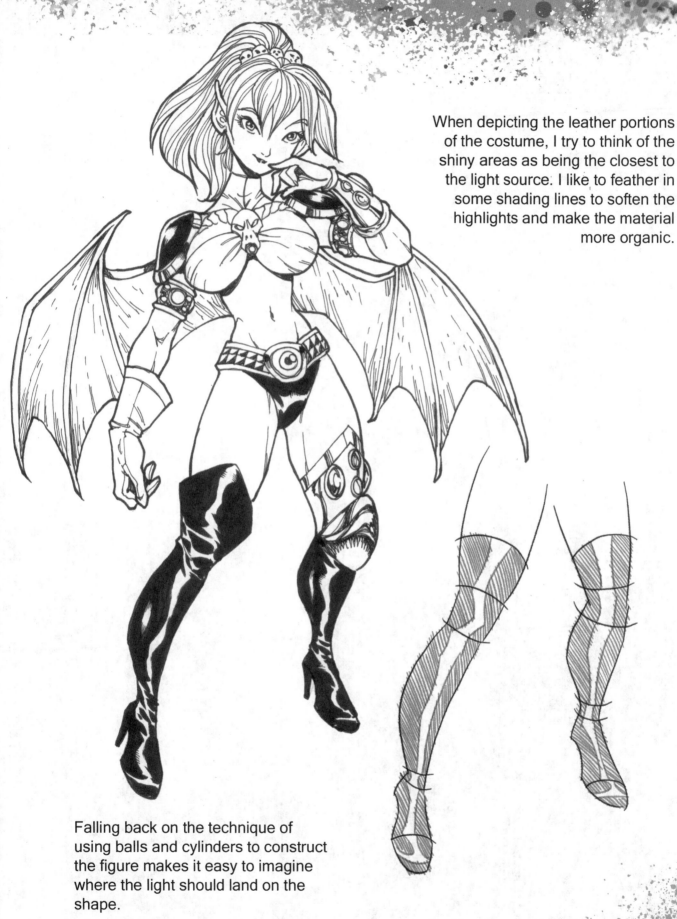

When depicting the leather portions of the costume, I try to think of the shiny areas as being the closest to the light source. I like to feather in some shading lines to soften the highlights and make the material more organic.

Falling back on the technique of using balls and cylinders to construct the figure makes it easy to imagine where the light should land on the shape.

I decided to shade the succubus with a soft edge. Using a hard edge might have made her seem more harsh than inviting.

Art: Ben Dunn

EXECUTIVE

Art: Ben Dunn

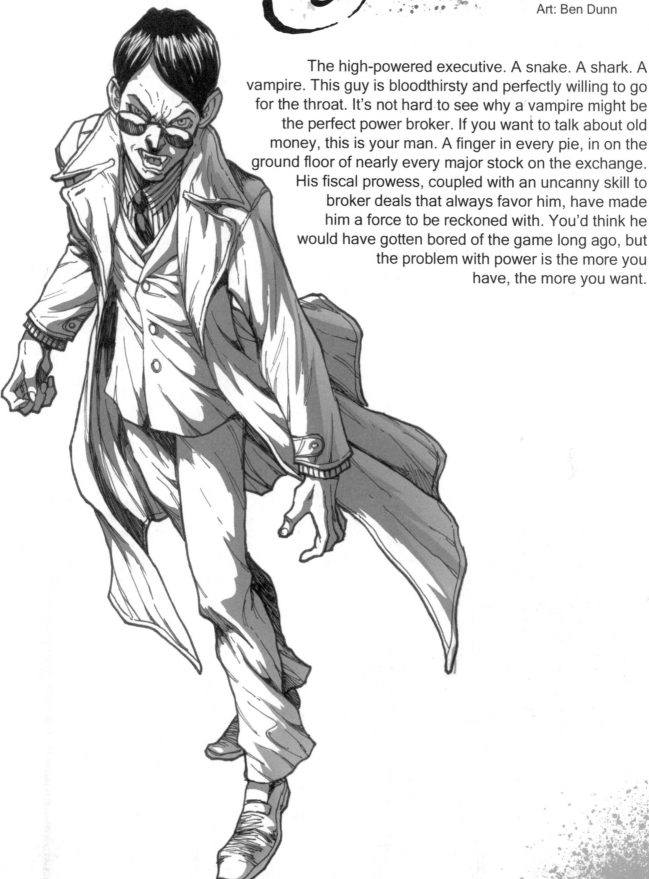

The high-powered executive. A snake. A shark. A vampire. This guy is bloodthirsty and perfectly willing to go for the throat. It's not hard to see why a vampire might be the perfect power broker. If you want to talk about old money, this is your man. A finger in every pie, in on the ground floor of nearly every major stock on the exchange. His fiscal prowess, coupled with an uncanny skill to broker deals that always favor him, have made him a force to be reckoned with. You'd think he would have gotten bored of the game long ago, but the problem with power is the more you have, the more you want.

I wanted to place the camera above the character. You can estimate the fore-shortening by eye, especially if you're familiar with drawing the human form at this angle.

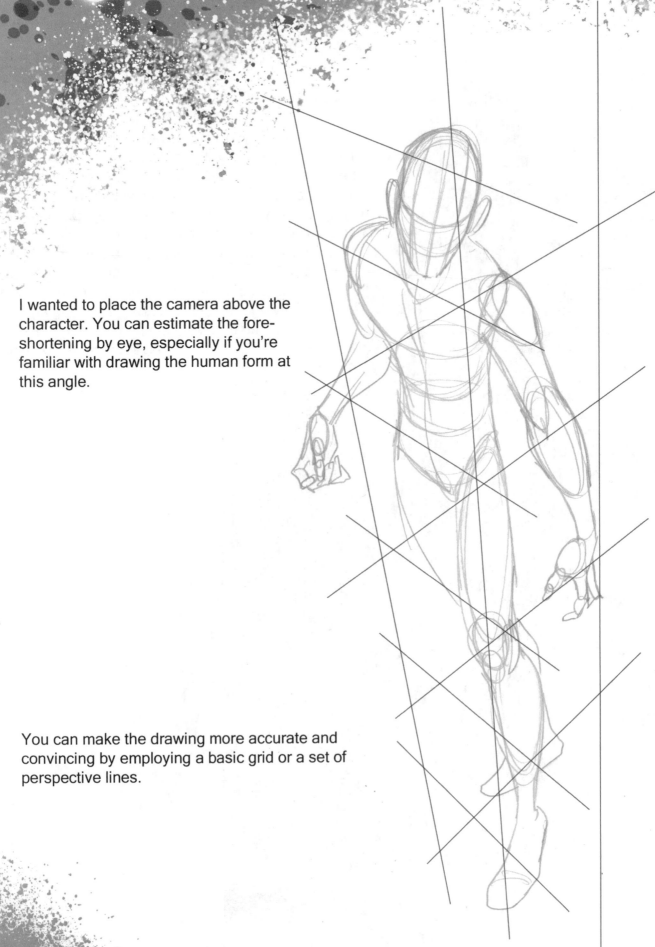

You can make the drawing more accurate and convincing by employing a basic grid or a set of perspective lines.

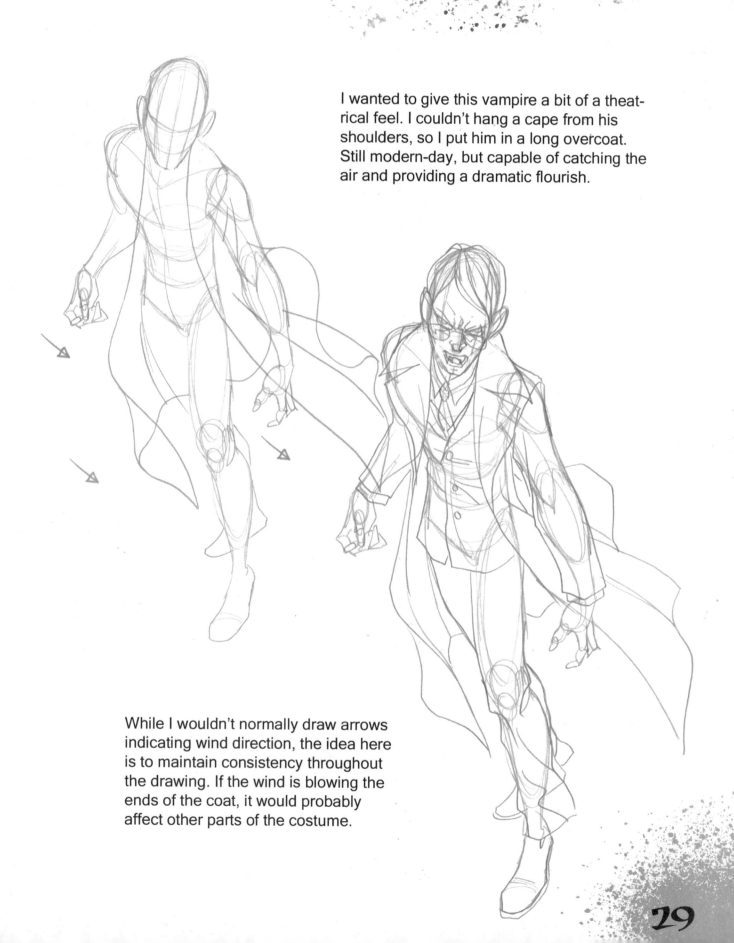

I wanted to give this vampire a bit of a theatrical feel. I couldn't hang a cape from his shoulders, so I put him in a long overcoat. Still modern-day, but capable of catching the air and providing a dramatic flourish.

While I wouldn't normally draw arrows indicating wind direction, the idea here is to maintain consistency throughout the drawing. If the wind is blowing the ends of the coat, it would probably affect other parts of the costume.

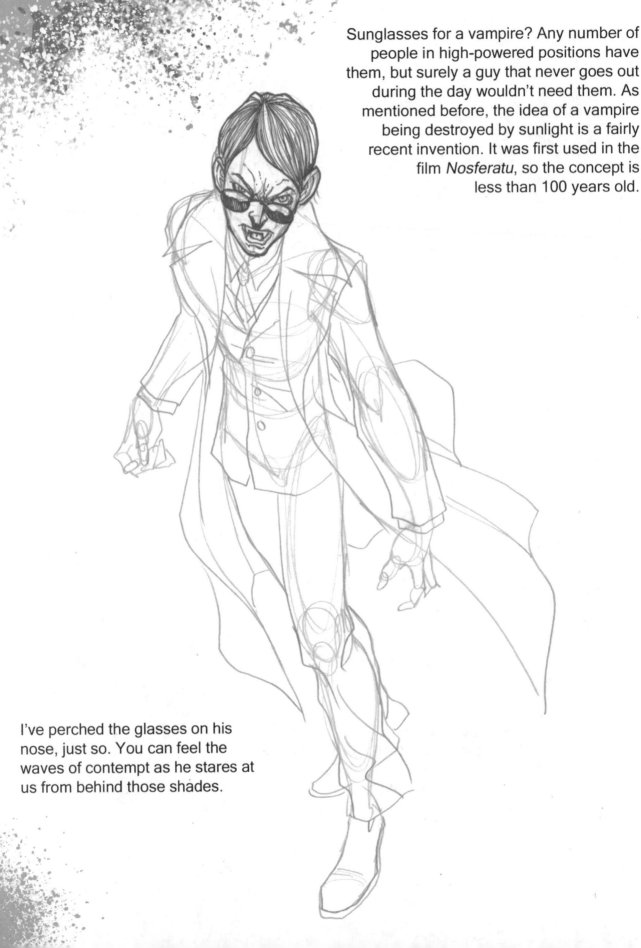

Sunglasses for a vampire? Any number of people in high-powered positions have them, but surely a guy that never goes out during the day wouldn't need them. As mentioned before, the idea of a vampire being destroyed by sunlight is a fairly recent invention. It was first used in the film *Nosferatu*, so the concept is less than 100 years old.

I've perched the glasses on his nose, just so. You can feel the waves of contempt as he stares at us from behind those shades.

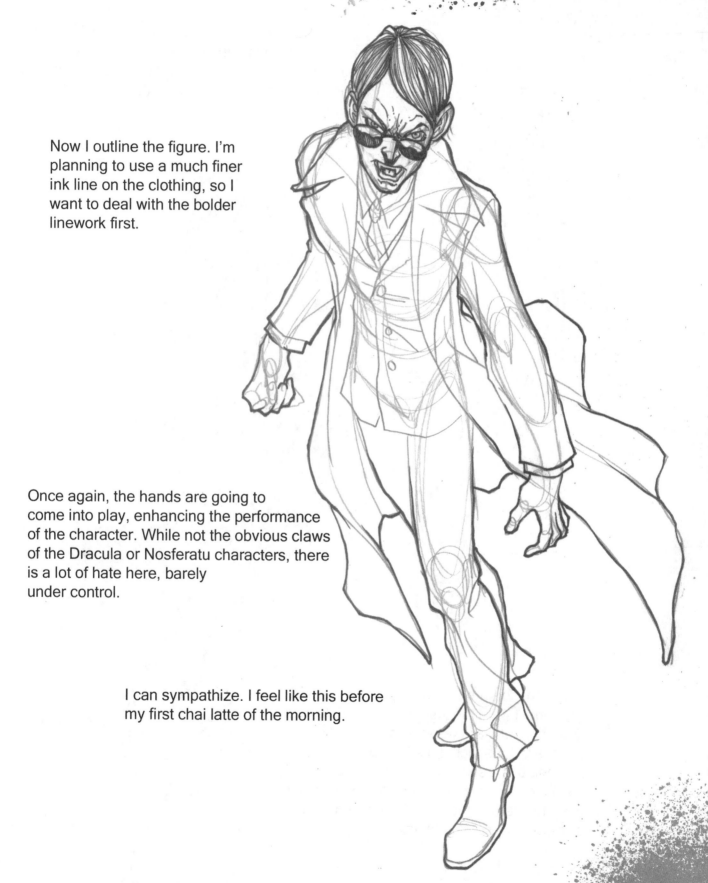

Now I outline the figure. I'm planning to use a much finer ink line on the clothing, so I want to deal with the bolder linework first.

Once again, the hands are going to come into play, enhancing the performance of the character. While not the obvious claws of the Dracula or Nosferatu characters, there is a lot of hate here, barely under control.

I can sympathize. I feel like this before my first chai latte of the morning.

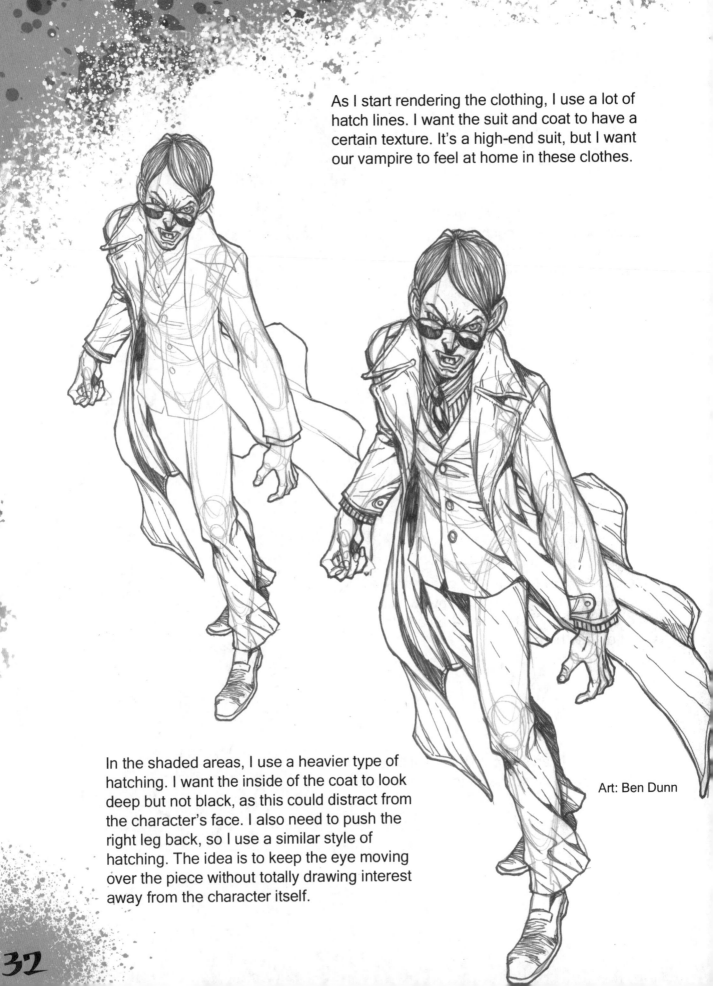

As I start rendering the clothing, I use a lot of hatch lines. I want the suit and coat to have a certain texture. It's a high-end suit, but I want our vampire to feel at home in these clothes.

In the shaded areas, I use a heavier type of hatching. I want the inside of the coat to look deep but not black, as this could distract from the character's face. I also need to push the right leg back, so I use a similar style of hatching. The idea is to keep the eye moving over the piece without totally drawing interest away from the character itself.

Art: Ben Dunn

GOTH

Art: Ben Dunn

The gothic scene has grown out of the mythos and imagery most associate with vampires. However, the movement has matured and gained an identity all its own.

For the pose, I wanted something a little less intimidating, more open or vulnerable.

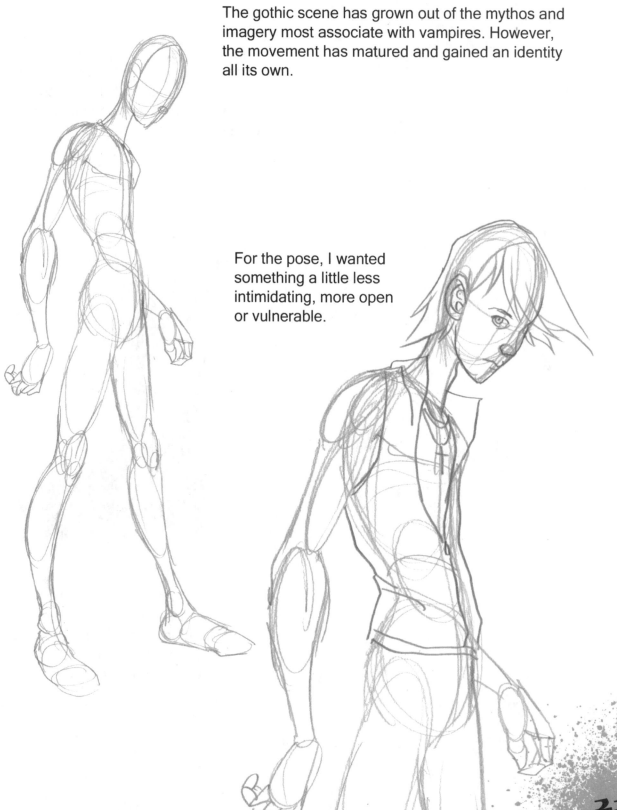

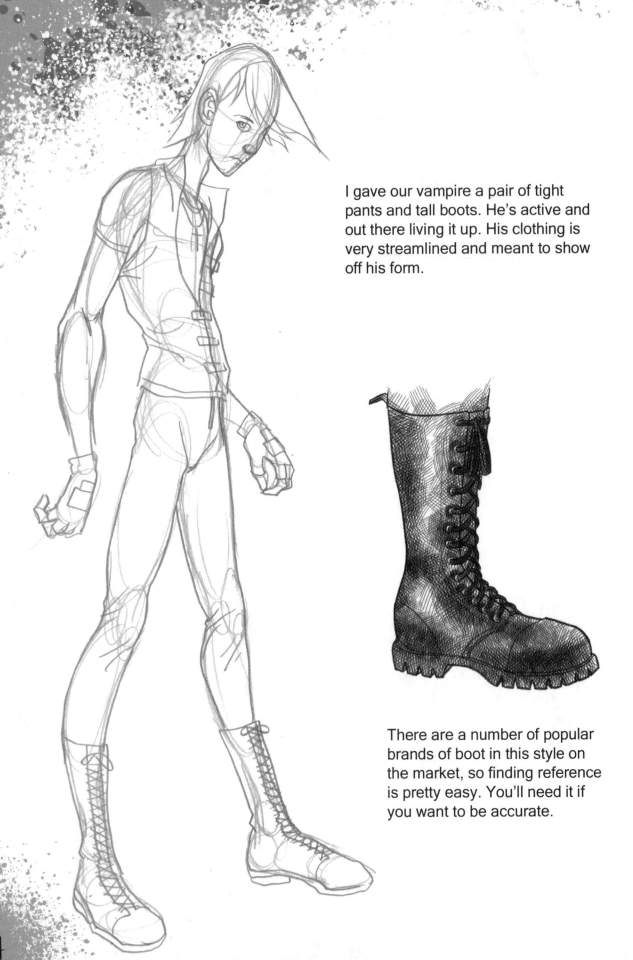

I gave our vampire a pair of tight pants and tall boots. He's active and out there living it up. His clothing is very streamlined and meant to show off his form.

There are a number of popular brands of boot in this style on the market, so finding reference is pretty easy. You'll need it if you want to be accurate.

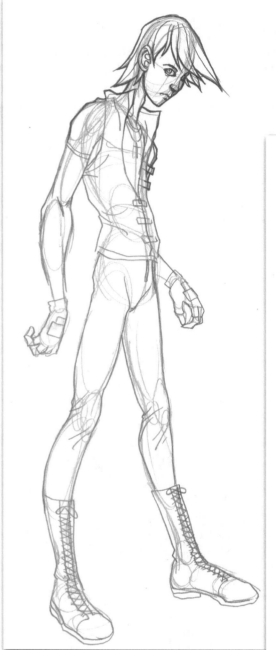

As I start inking the figure, I want to keep the lines sharp and slightly angular. I make the collar sharp as well; I want it to be reminiscent of the collar on a traditional vampire's cape.

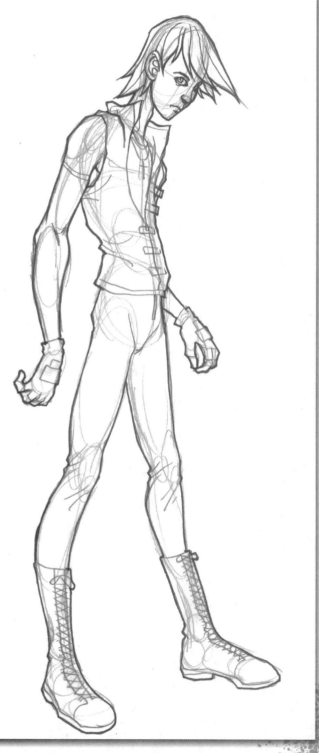

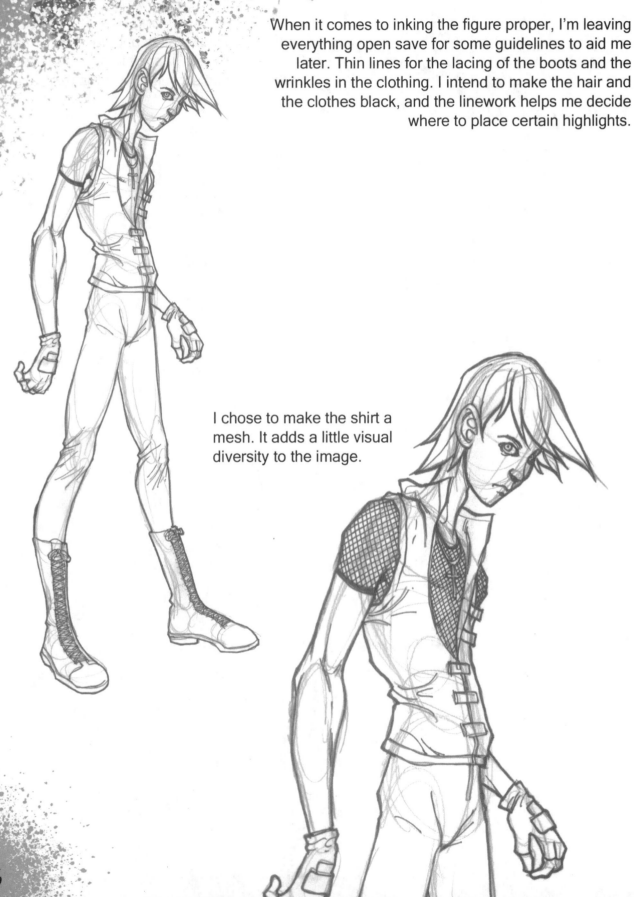

When it comes to inking the figure proper, I'm leaving everything open save for some guidelines to aid me later. Thin lines for the lacing of the boots and the wrinkles in the clothing. I intend to make the hair and the clothes black, and the linework helps me decide where to place certain highlights.

I chose to make the shirt a mesh. It adds a little visual diversity to the image.

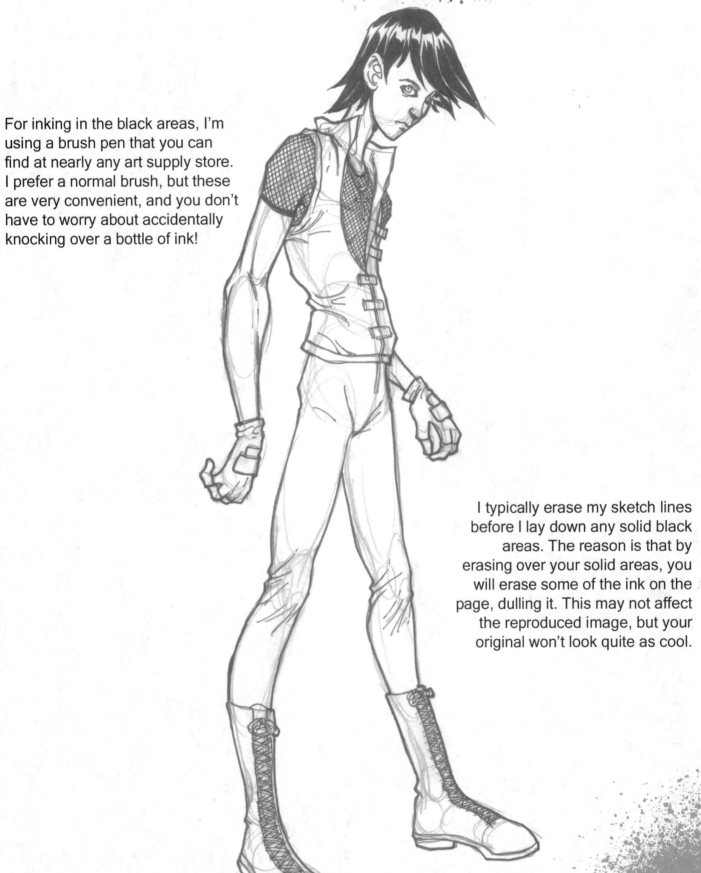

For inking in the black areas, I'm using a brush pen that you can find at nearly any art supply store. I prefer a normal brush, but these are very convenient, and you don't have to worry about accidentally knocking over a bottle of ink!

I typically erase my sketch lines before I lay down any solid black areas. The reason is that by erasing over your solid areas, you will erase some of the ink on the page, dulling it. This may not affect the reproduced image, but your original won't look quite as cool.

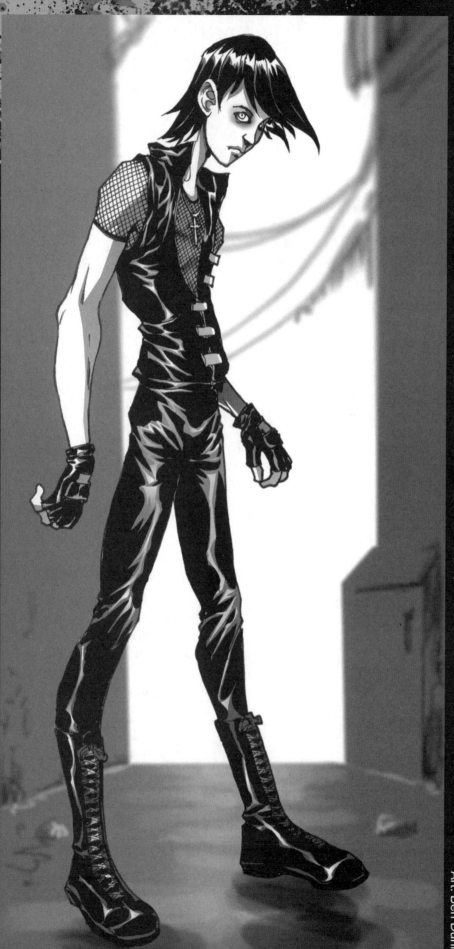

To finish off the piece, I do some hard-edged shading similar to the linework I employed when inking the drawing. I decided on an alley as the setting. This could just as easily have been the interior of a nightclub.

As long as it's dark and dangerous, this vampire will feel right at home.

Art: Ben Dunn

GOTH

Art: Ben Dunn

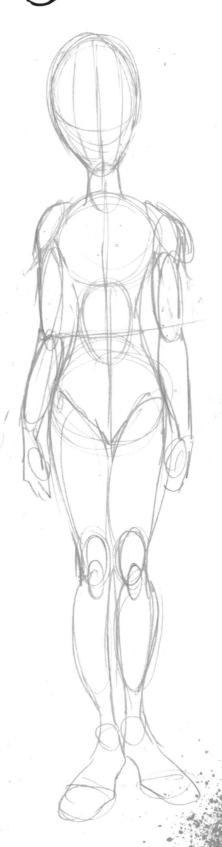

For this goth vampire, I'm going for something less frilly than what we would find in the Gothic Lolita style. More of rocker type.

For the pose, I give this vampire a bit of a slouch, with a slope to the shoulders and an inclined head. This is someone who's seen it all and bit more. There's nothing worse than a bored vampire, and immortality offers plenty of opportunities to be bored.

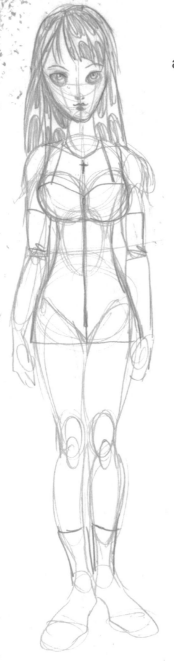

Our vampire has long hair. As I was drawing, I thought about doing something a little different, so I added tails to either side of her head.

I went with a one-piece leather mini for the dress, long stockings and arm-length gloves. Depending on how the material is cut, it could be skin-tight, without many wrinkles or creases.

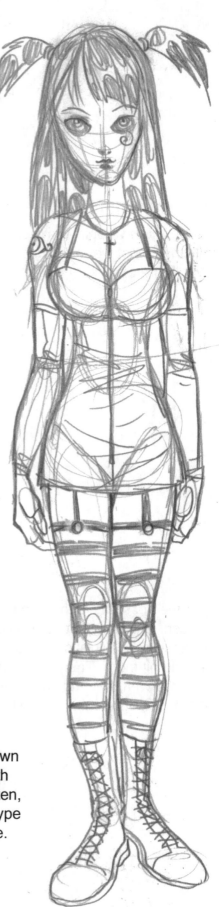

The kind of boot shown here is worn by both men and women. Often, women will use the type with a platform sole.

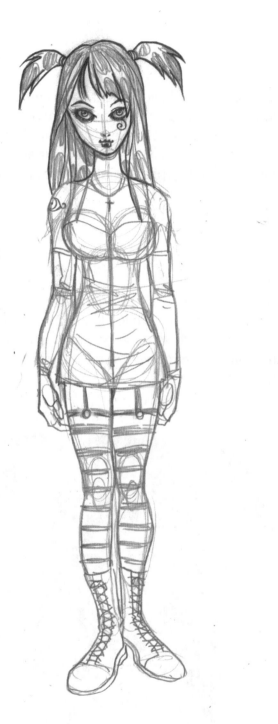

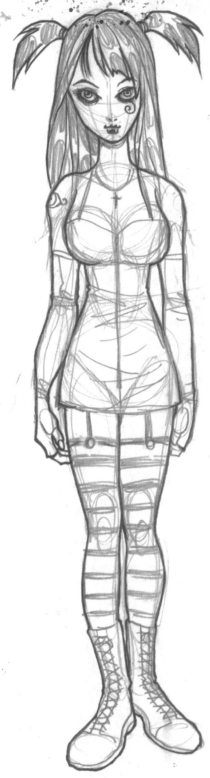

Inking this character is a fairly simple process once the basic look and costuming are taken care of. Again, make sure to have some good reference on hand. If you have time, try practicing various inking techniques you might want to use on a separate sheet or even a photocopy of the drawing you're working on.

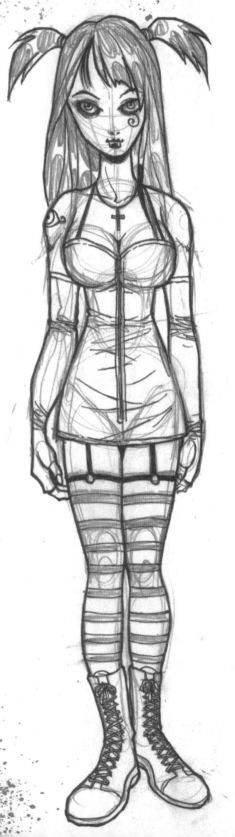

As you can see, I've concentrated my hatch lines around the eyes to give them a more sunken appearance. I've also taken time to add some tattoos reminiscent of what we might see in Egyptian-related imagery.

Now I ink in the lines I'll need when I do the final inks for the piece. While I'll use these lines to ink in the dress, gloves and boots, I won't do this for the hair, as I've done some toning in pencil to guide me.

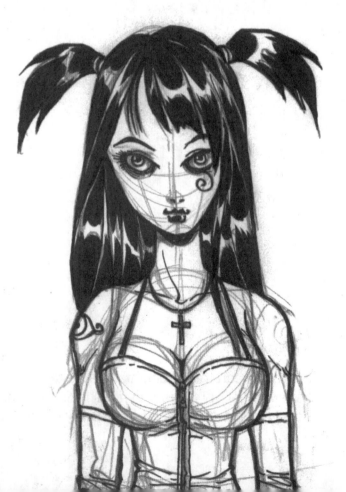

Now our undead friend is starting to look a little more alive!

Remember when you are depicting skintight clothing that regardless of how tight the garment is, some areas will drape, hang and crease. Feel free to use artistic license, but don't strain your credibility too far!

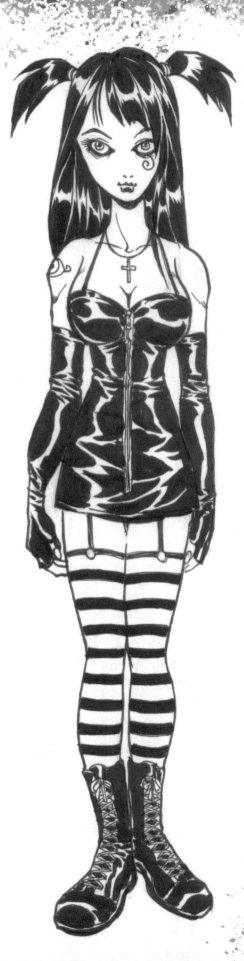

Demonic
Art: David Hutchison

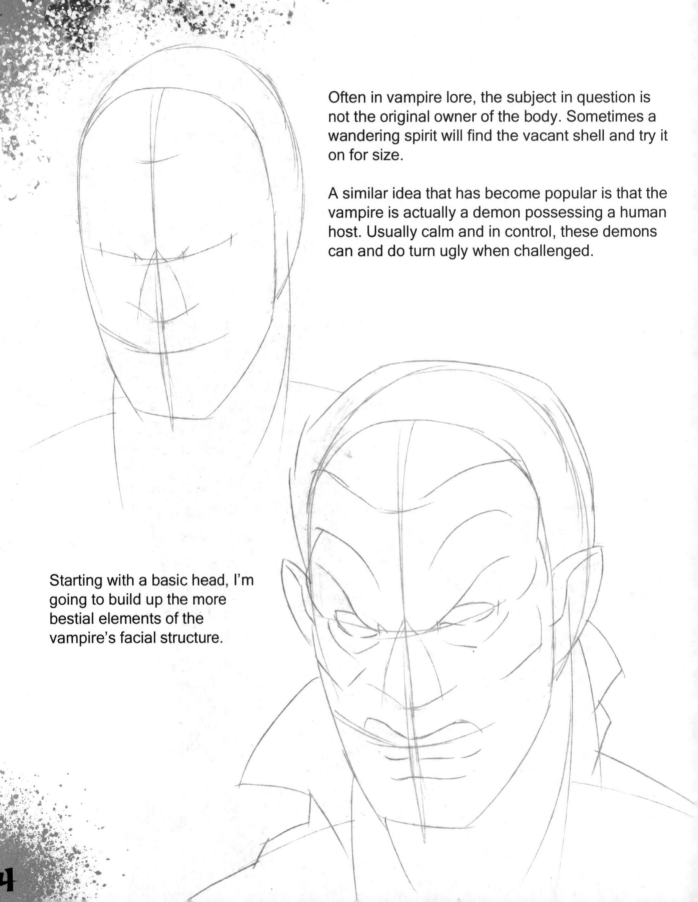

Often in vampire lore, the subject in question is not the original owner of the body. Sometimes a wandering spirit will find the vacant shell and try it on for size.

A similar idea that has become popular is that the vampire is actually a demon possessing a human host. Usually calm and in control, these demons can and do turn ugly when challenged.

Starting with a basic head, I'm going to build up the more bestial elements of the vampire's facial structure.

Here I'm continuing to build up the facial elements, furrowing the brow and the bridge of the nose, and making the cheekbones more pronounced.

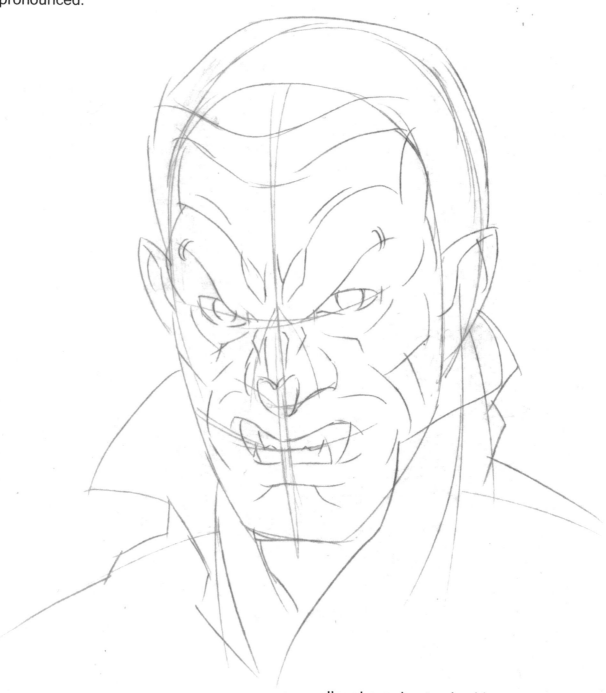

I'm also going to give him some fangs better suited to a lion. This guy is meant to be savage, a real brute.

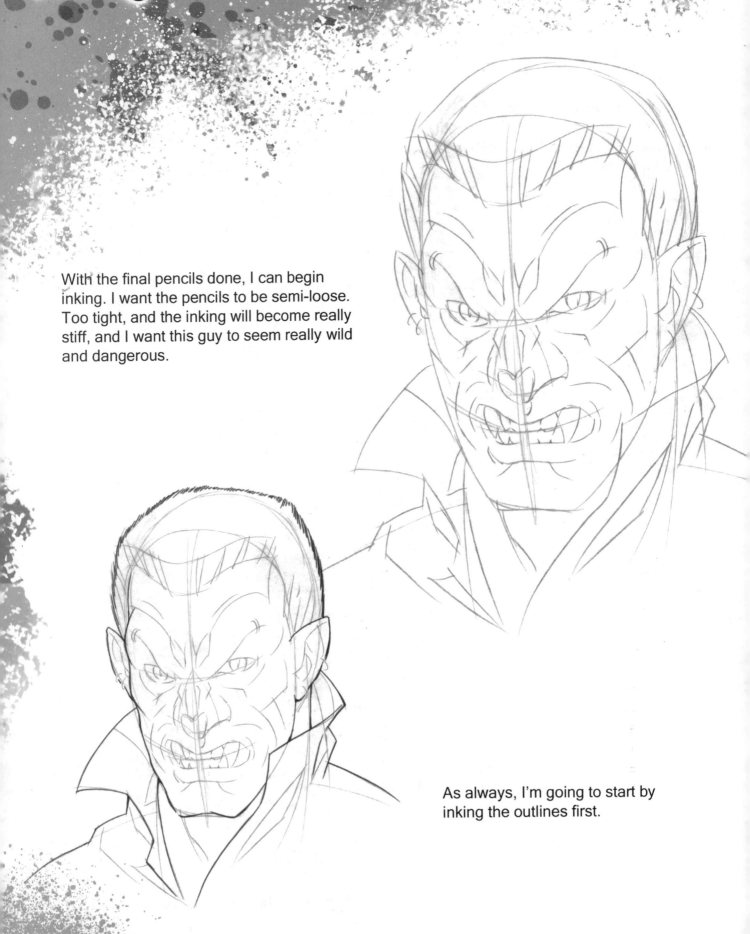

With the final pencils done, I can begin inking. I want the pencils to be semi-loose. Too tight, and the inking will become really stiff, and I want this guy to seem really wild and dangerous.

As always, I'm going to start by inking the outlines first.

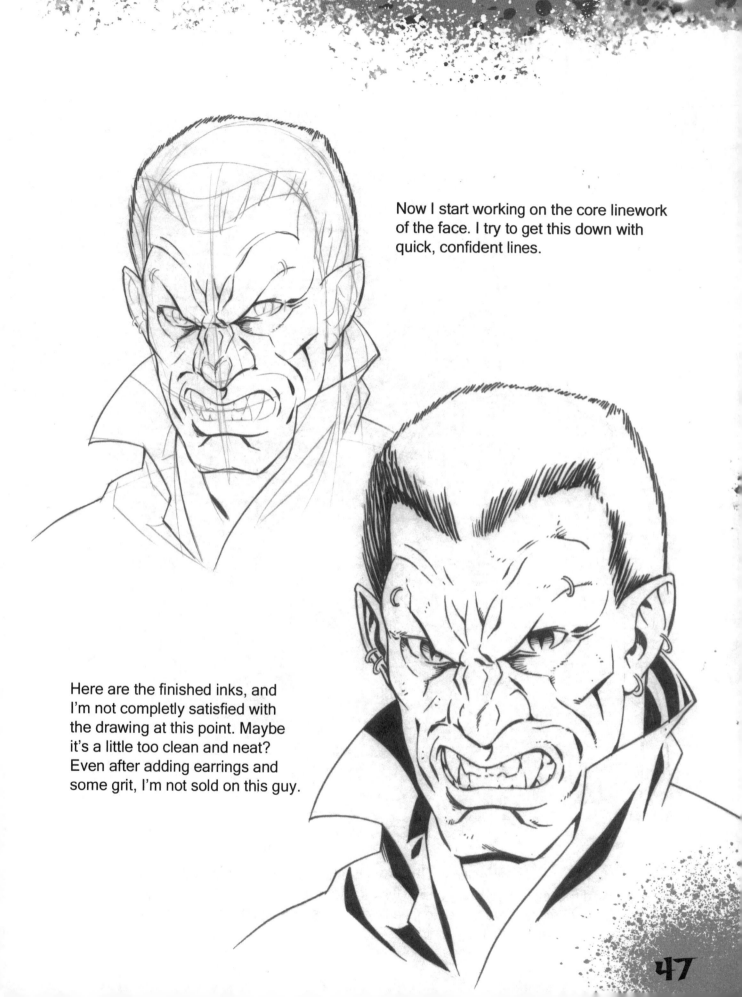

Now I start working on the core linework of the face. I try to get this down with quick, confident lines.

Here are the finished inks, and I'm not completely satisfied with the drawing at this point. Maybe it's a little too clean and neat? Even after adding earrings and some grit, I'm not sold on this guy.

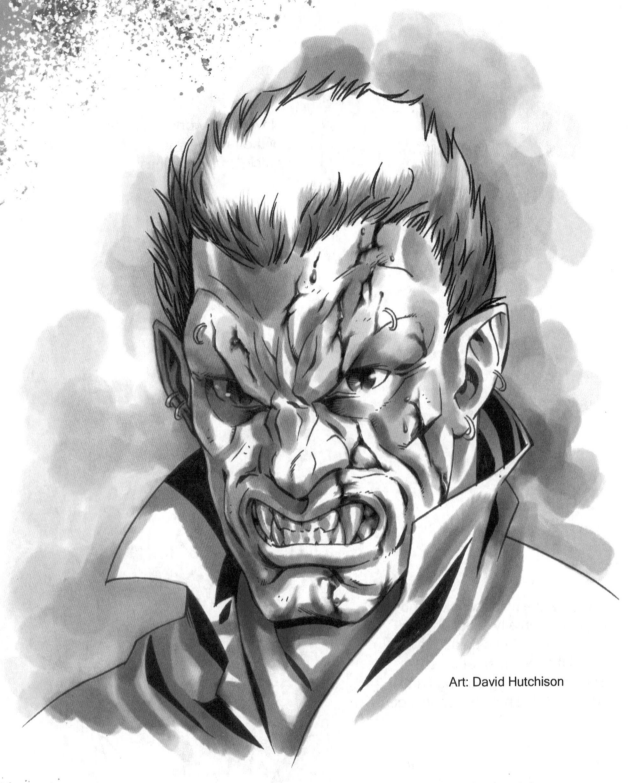

Art: David Hutchison

Now this is more like it! Changing the hair was a big step in the right direction. Once I was happy with the hair, I dropped in some tones to give the piece a more definite light source. Finally, the blood, to make it seem as if he's been in battle.

Blutsauger

The exploits of the Third Reich are well known, as was their willingness to dabble in the occult. Germany, in the years leading up to and during WW2, supported any program that had the potential to give the Axis powers an upper hand.

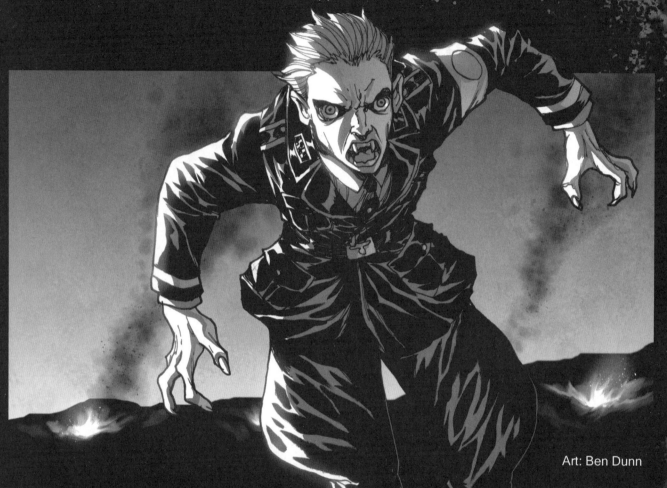

Art: Ben Dunn

What better soldier could there be than one that doesn't have to sleep, doesn't tire, has superhuman strength, and feeds on his enemies for nourishment?

This vampire's company found out that there's a big problem with giving the powers of a monster to somebody who already is one.

Reference for WW2-era German soldiers can be found far and wide, so it shouldn't prove too difficult to find what you need.

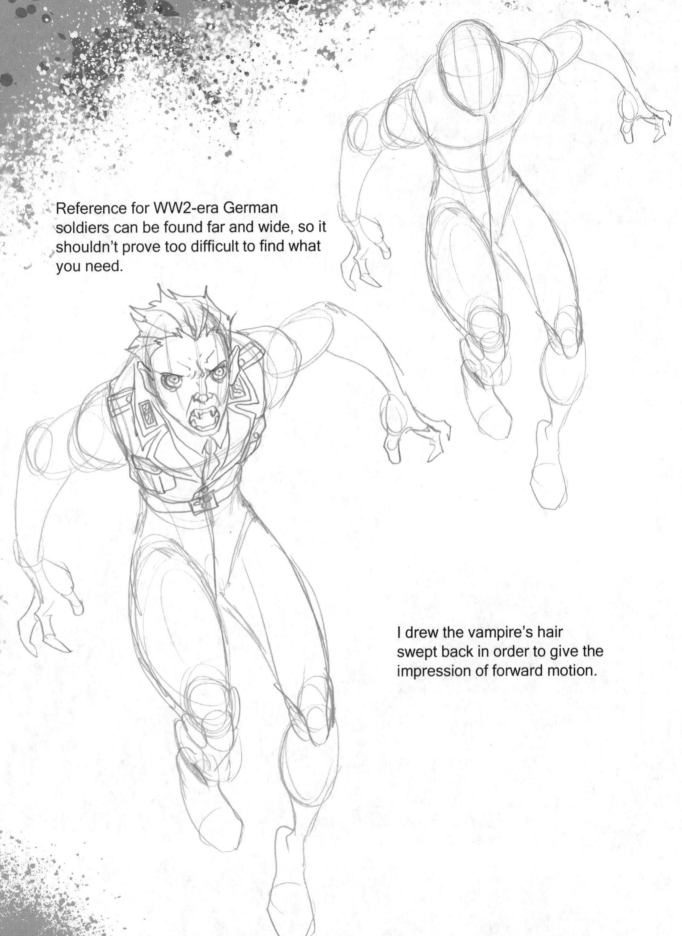

I drew the vampire's hair swept back in order to give the impression of forward motion.

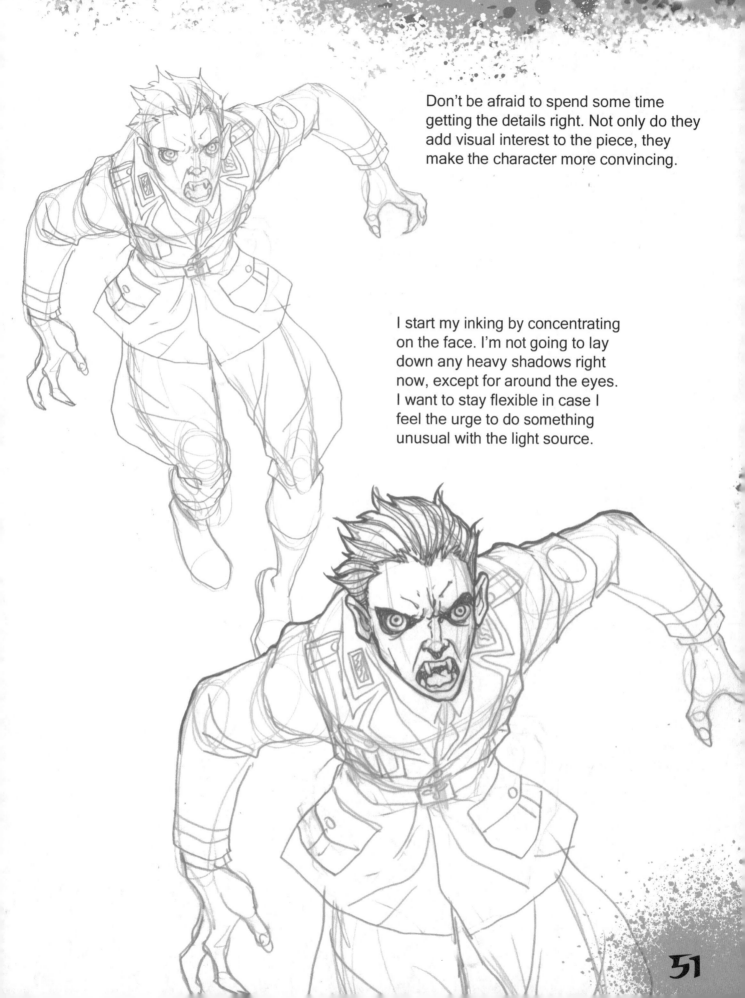

Don't be afraid to spend some time getting the details right. Not only do they add visual interest to the piece, they make the character more convincing.

I start my inking by concentrating on the face. I'm not going to lay down any heavy shadows right now, except for around the eyes. I want to stay flexible in case I feel the urge to do something unusual with the light source.

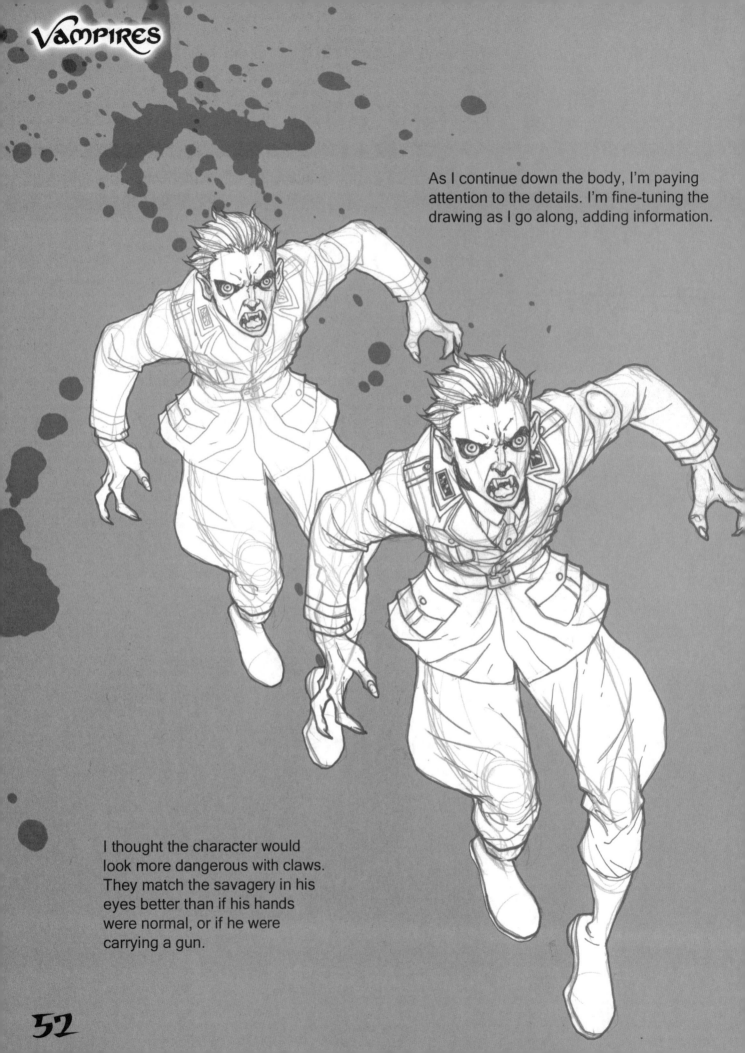

As I continue down the body, I'm paying attention to the details. I'm fine-tuning the drawing as I go along, adding information.

I thought the character would look more dangerous with claws. They match the savagery in his eyes better than if his hands were normal, or if he were carrying a gun.

I'm going to place the light source somewhere behind the character, so I'm leaving a large, highlighted area in the direction the light will come from.

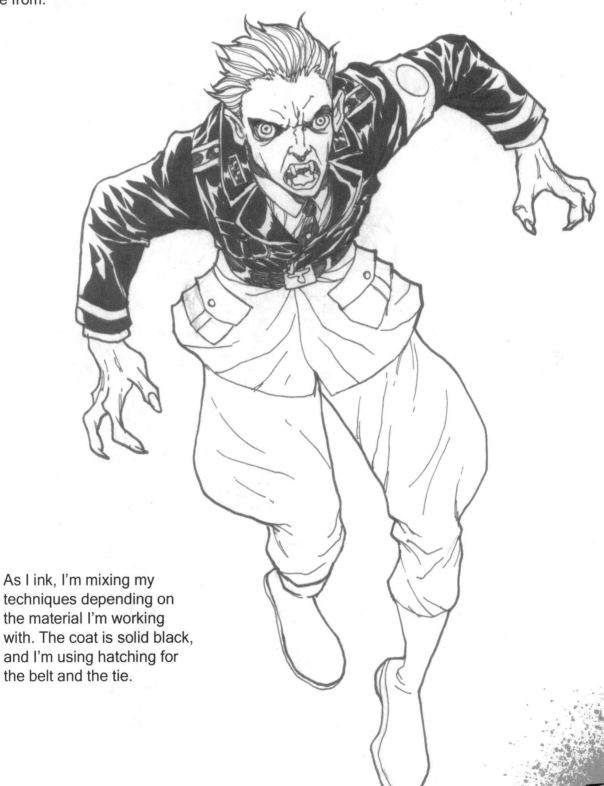

As I ink, I'm mixing my techniques depending on the material I'm working with. The coat is solid black, and I'm using hatching for the belt and the tie.

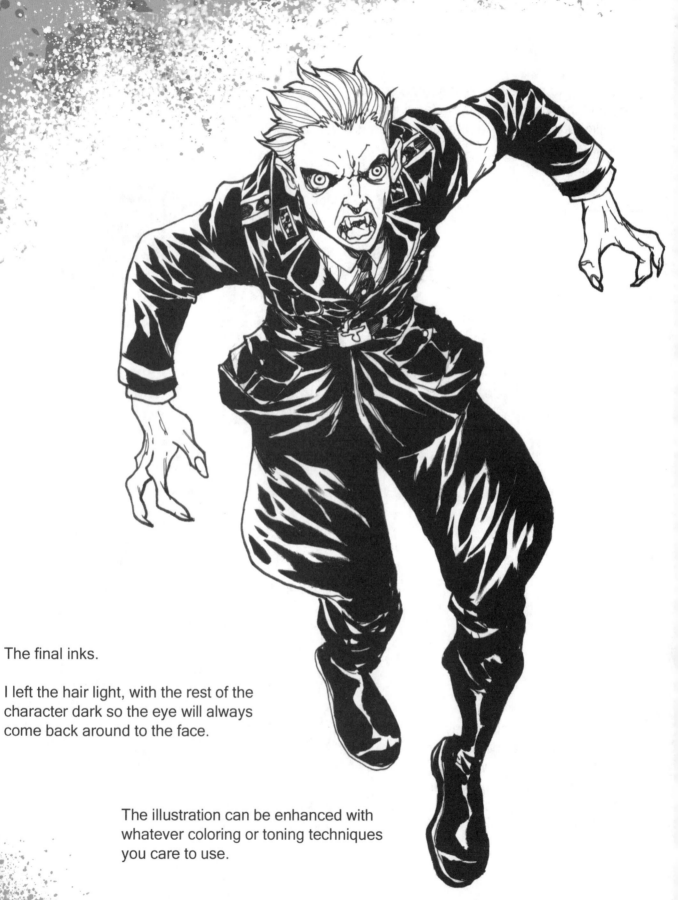

The final inks.

I left the hair light, with the rest of the character dark so the eye will always come back around to the face.

The illustration can be enhanced with whatever coloring or toning techniques you care to use.

Art: David Hutchison

In this case, we're trying to design a warrior meant to do battle for the Vampire nation. Vampires have powerful enemies who often vie for the same resources and constantly watch for signs of weakness.

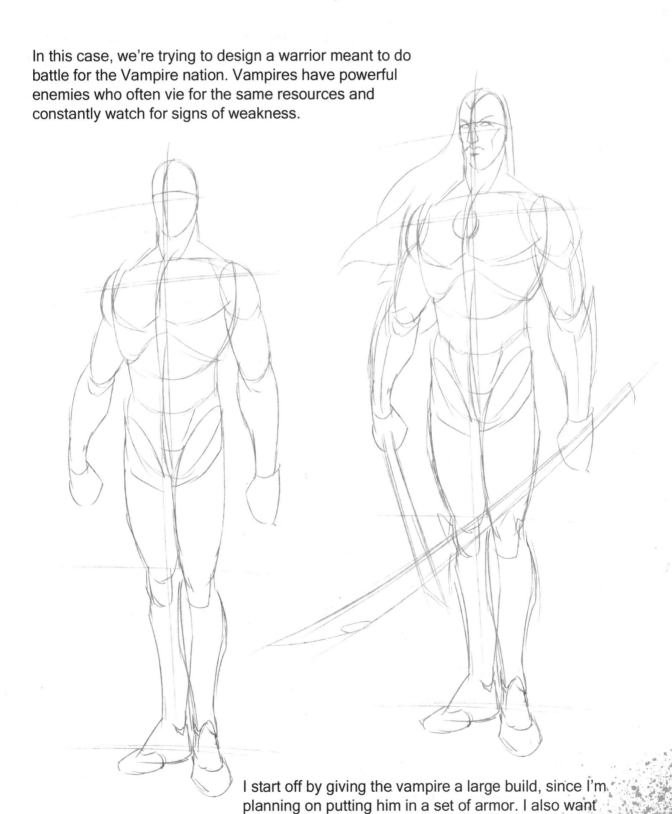

I start off by giving the vampire a large build, since I'm planning on putting him in a set of armor. I also want him to seem even more powerful than most vampires.

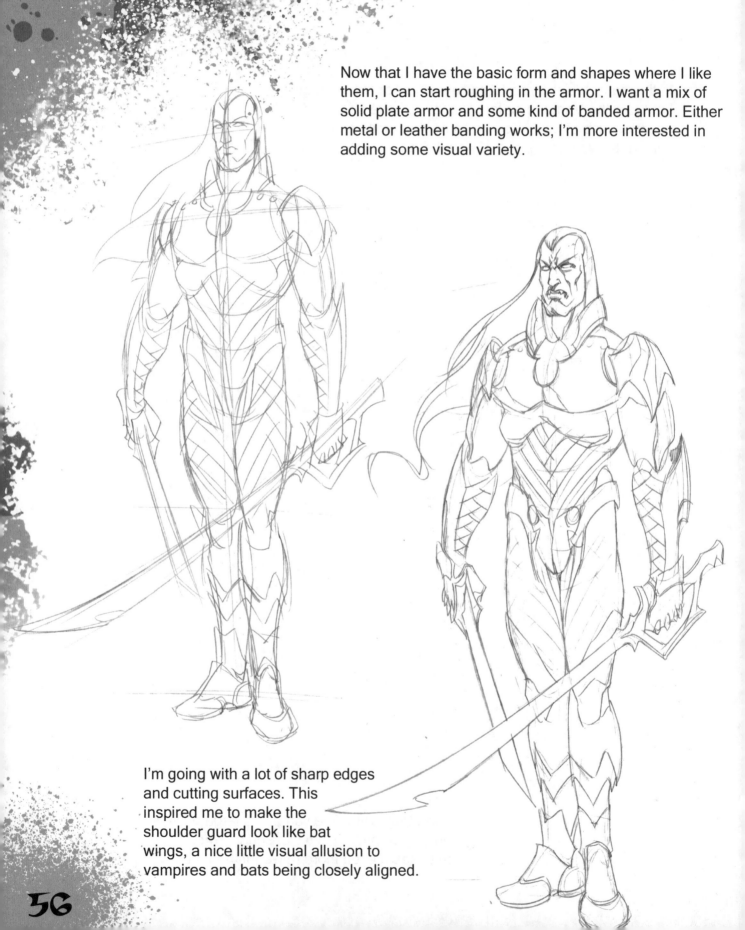

Now that I have the basic form and shapes where I like them, I can start roughing in the armor. I want a mix of solid plate armor and some kind of banded armor. Either metal or leather banding works; I'm more interested in adding some visual variety.

I'm going with a lot of sharp edges and cutting surfaces. This inspired me to make the shoulder guard look like bat wings, a nice little visual allusion to vampires and bats being closely aligned.

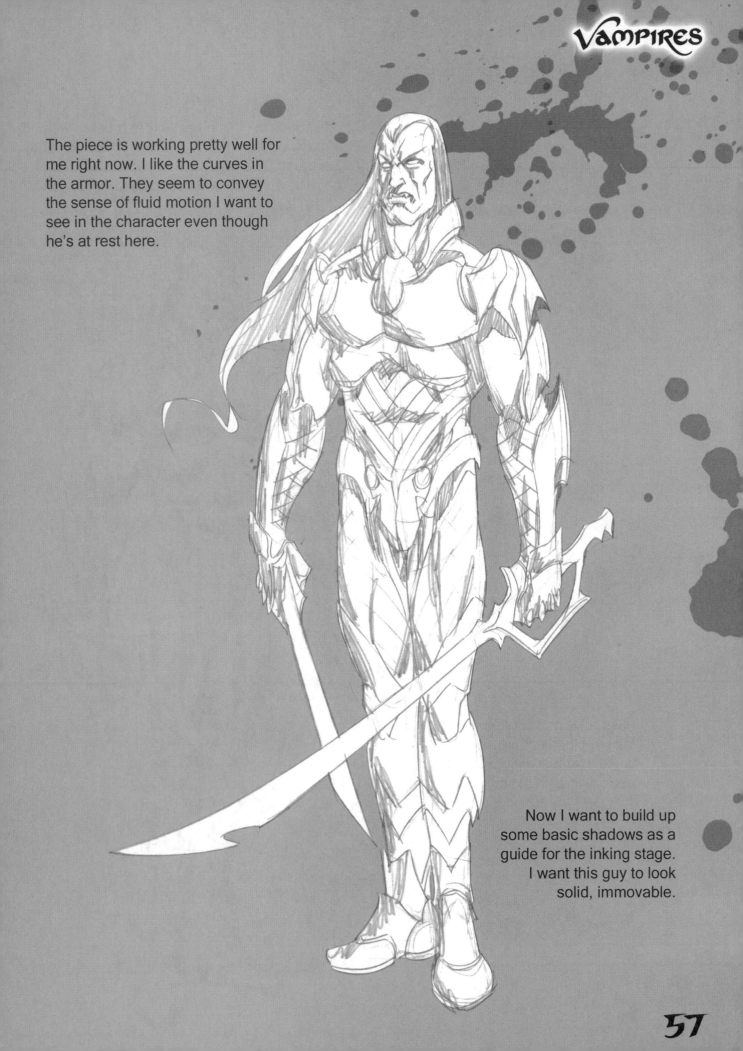

The piece is working pretty well for me right now. I like the curves in the armor. They seem to convey the sense of fluid motion I want to see in the character even though he's at rest here.

Now I want to build up some basic shadows as a guide for the inking stage. I want this guy to look solid, immovable.

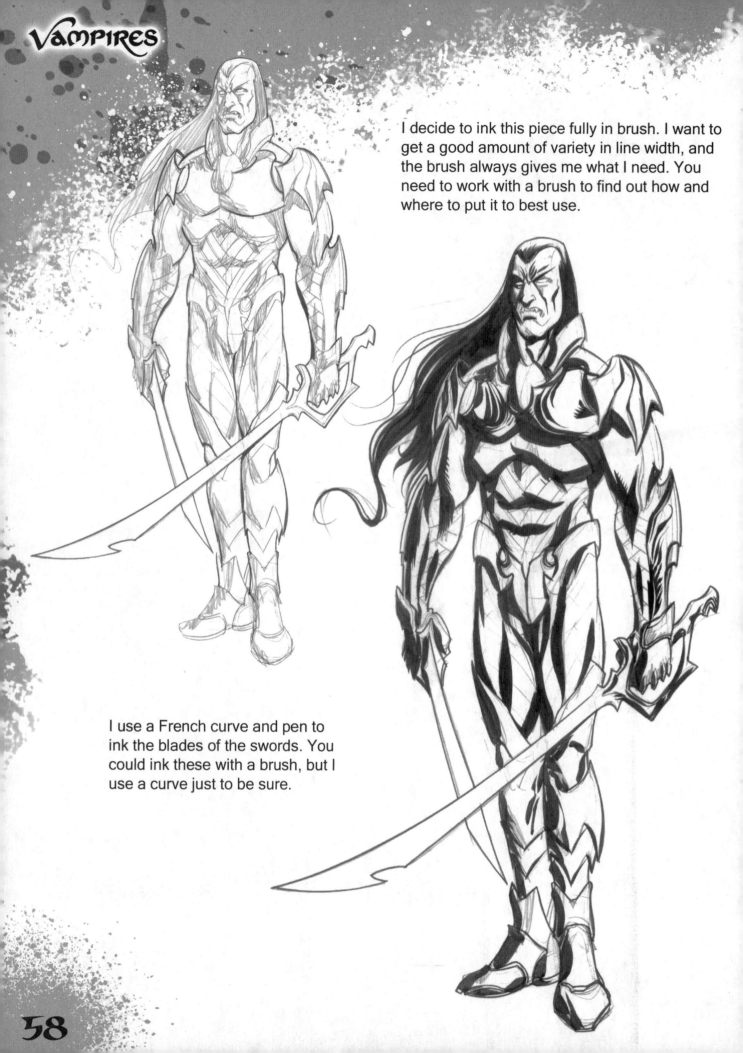

I decide to ink this piece fully in brush. I want to get a good amount of variety in line width, and the brush always gives me what I need. You need to work with a brush to find out how and where to put it to best use.

I use a French curve and pen to ink the blades of the swords. You could ink these with a brush, but I use a curve just to be sure.

Once the inking is done, I tone the piece. For the armor and the swords, I give a slight texture, trying to show the age and use of the materials.

I could have added some blood to the figure, but I was more interested in the design aspects of the piece. You can enhance your own drawing any way you want.

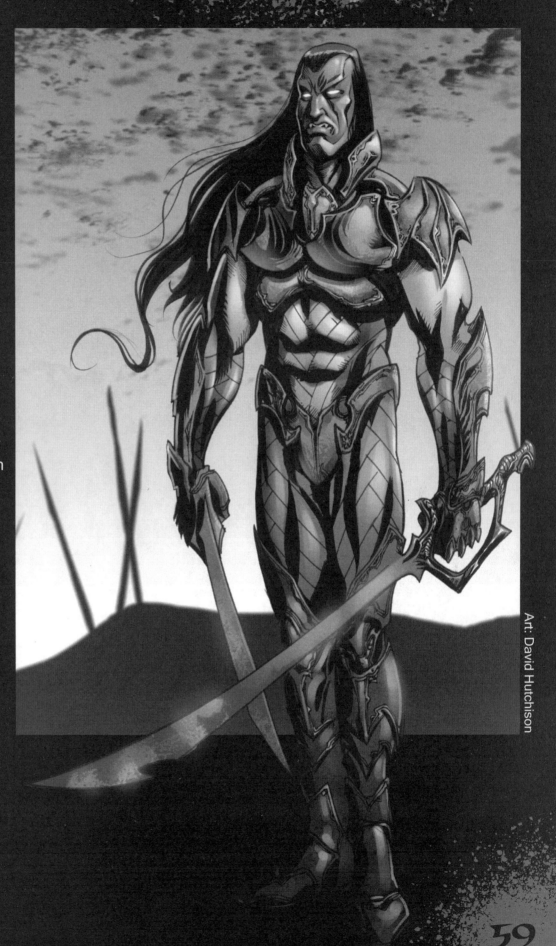

Art: David Hutchison

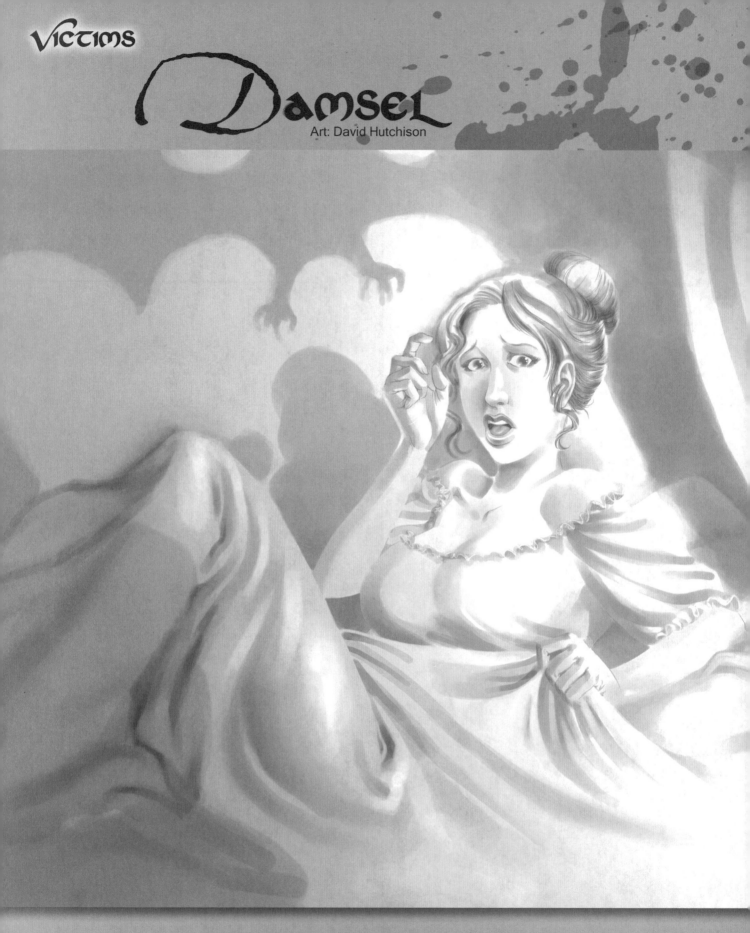

Damsel

Art: David Hutchison

Ah, yes. The damsel, or *dinner*, as a vampire would say. While the damsel is a convenient source of blood, all too often, something about her will remind a vampire of a loved one from the distant past, and genuine emotions soon follow. This can lead to fatal mistakes. Woe betide the vampire who has the misfortune to fall for her.

Since I want to show the
character sitting up in bed, I draw
a motion line showing the
general position of the figure and
the angles of the shoulders and
hips. This is an important guide,
as the lower part of the body will
be hidden under sheets.

I want to depict the character caught off
guard, surprised. So I bend the arms and
legs, and bring the hand up to the face. I
just want to keep the eye moving around
the image and make the form more
interesting.

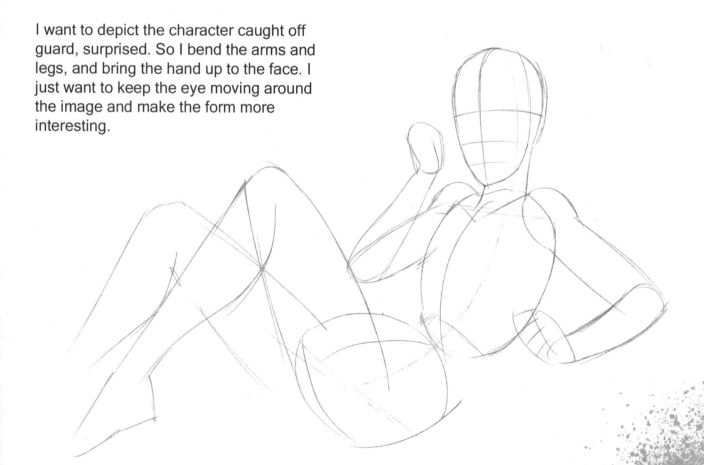

Now I build up the details, especially the facial features. The sheets take up most of the picture, so I spend some time getting the folds right.

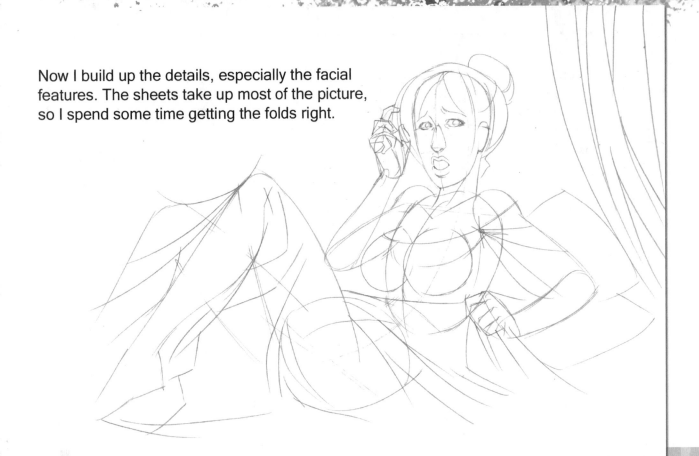

I'm going staight into the toning on this piece. For the painted style I'm using, I like to start out using the largest brush that I can get away with and reduce the size as I refine the art.

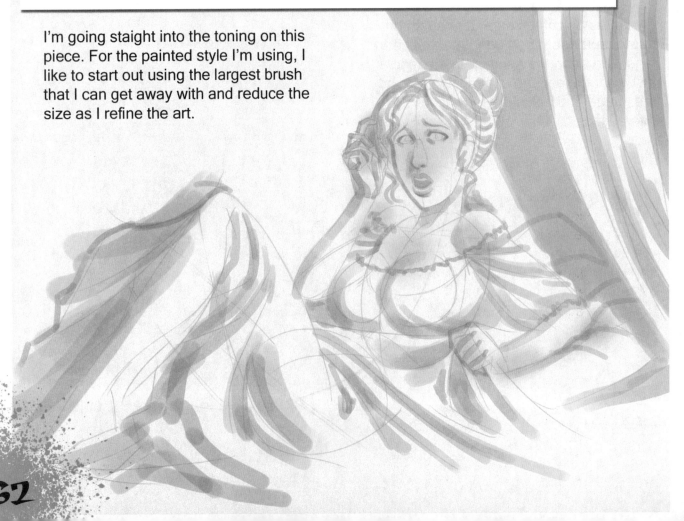

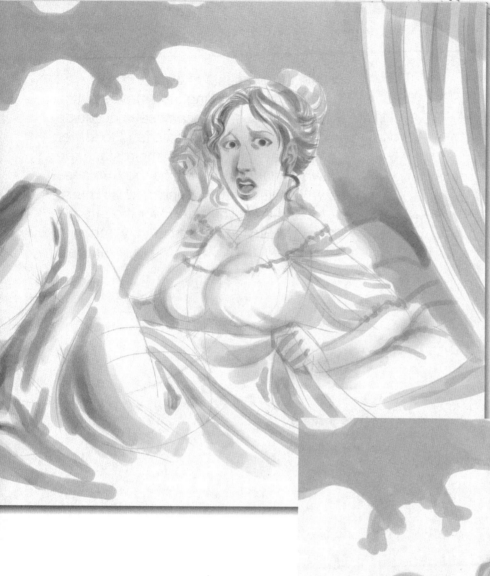

Once I have the basic tones down, I start introducing darker shading into the low-light areas and building up volume in the girl's hair.

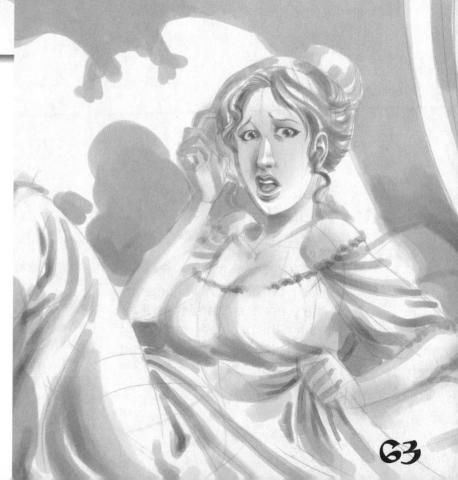

I deepen the levels of tone in the piece. Once the rough painting is done, I start tackling the most important areas and refine the rendering. I work outward from the face and hands to finish off the illustration.

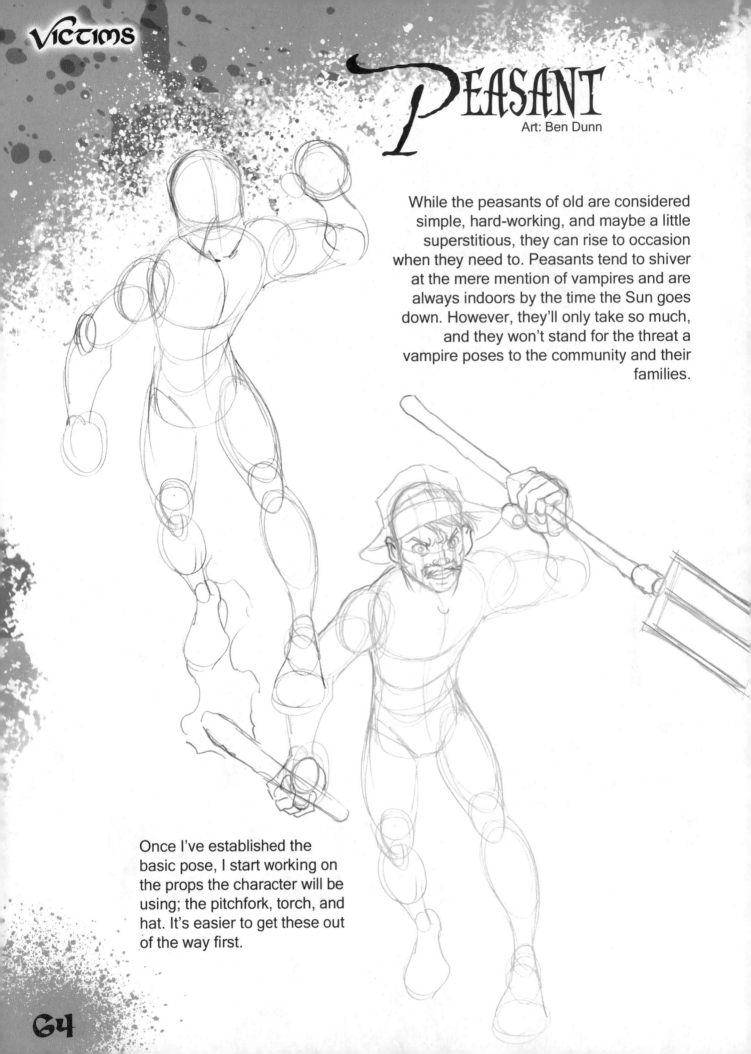

Peasant

Art: Ben Dunn

While the peasants of old are considered simple, hard-working, and maybe a little superstitious, they can rise to occasion when they need to. Peasants tend to shiver at the mere mention of vampires and are always indoors by the time the Sun goes down. However, they'll only take so much, and they won't stand for the threat a vampire poses to the community and their families.

Once I've established the basic pose, I start working on the props the character will be using; the pitchfork, torch, and hat. It's easier to get these out of the way first.

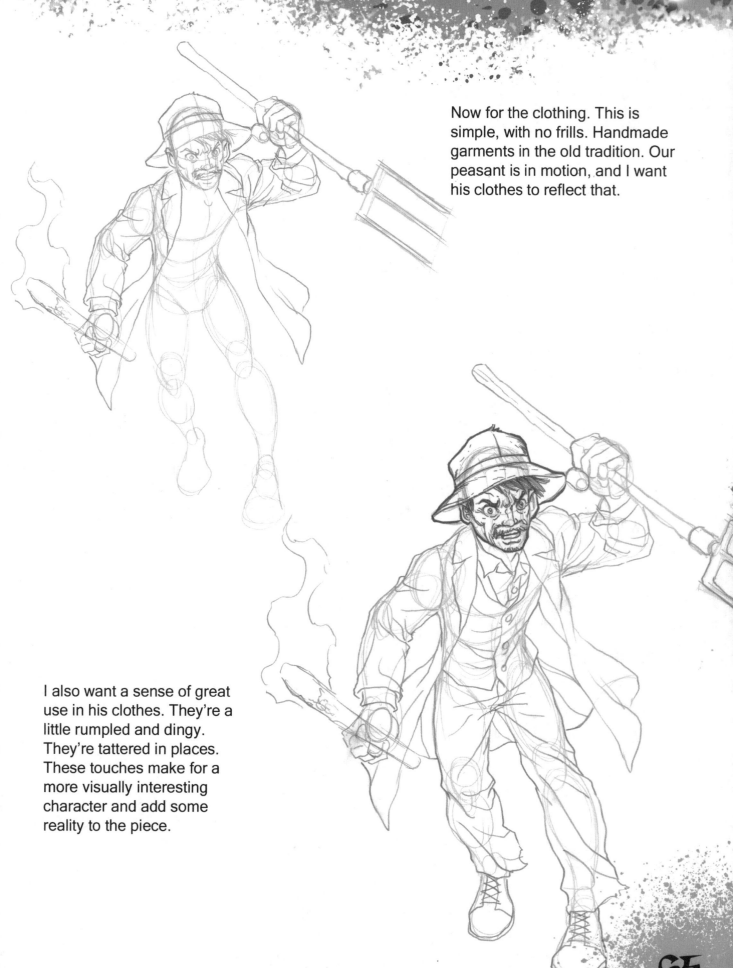

Now for the clothing. This is simple, with no frills. Handmade garments in the old tradition. Our peasant is in motion, and I want his clothes to reflect that.

I also want a sense of great use in his clothes. They're a little rumpled and dingy. They're tattered in places. These touches make for a more visually interesting character and add some reality to the piece.

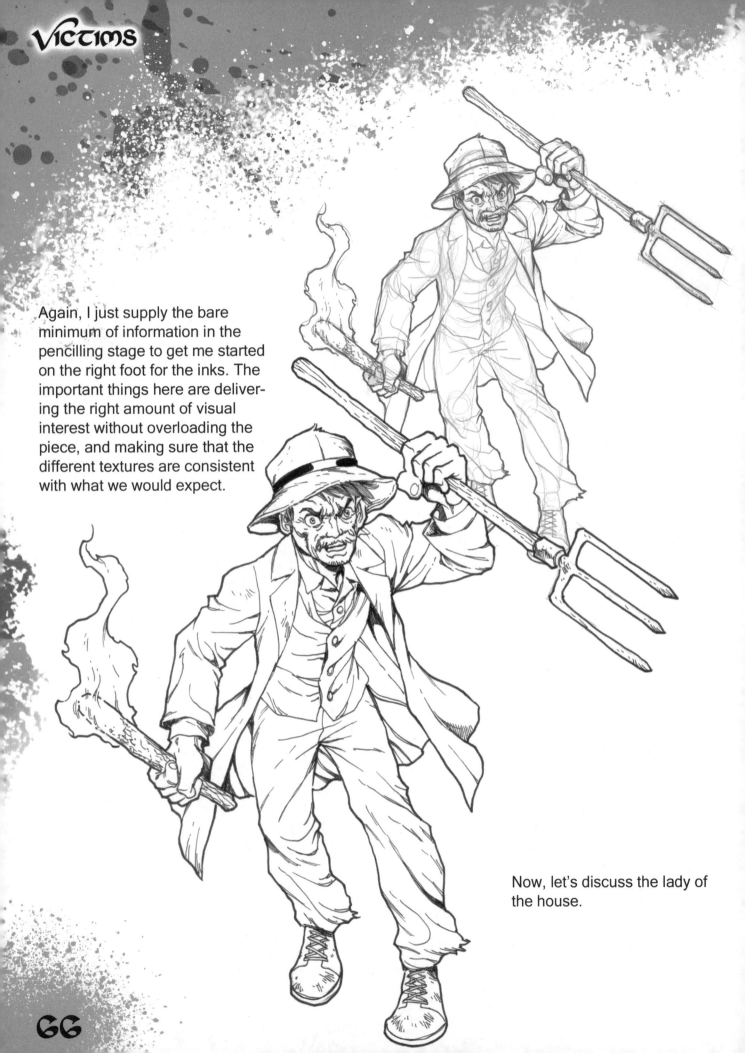

Again, I just supply the bare minimum of information in the pencilling stage to get me started on the right foot for the inks. The important things here are delivering the right amount of visual interest without overloading the piece, and making sure that the different textures are consistent with what we would expect.

Now, let's discuss the lady of the house.

PEASANT

Art: Ben Dunn

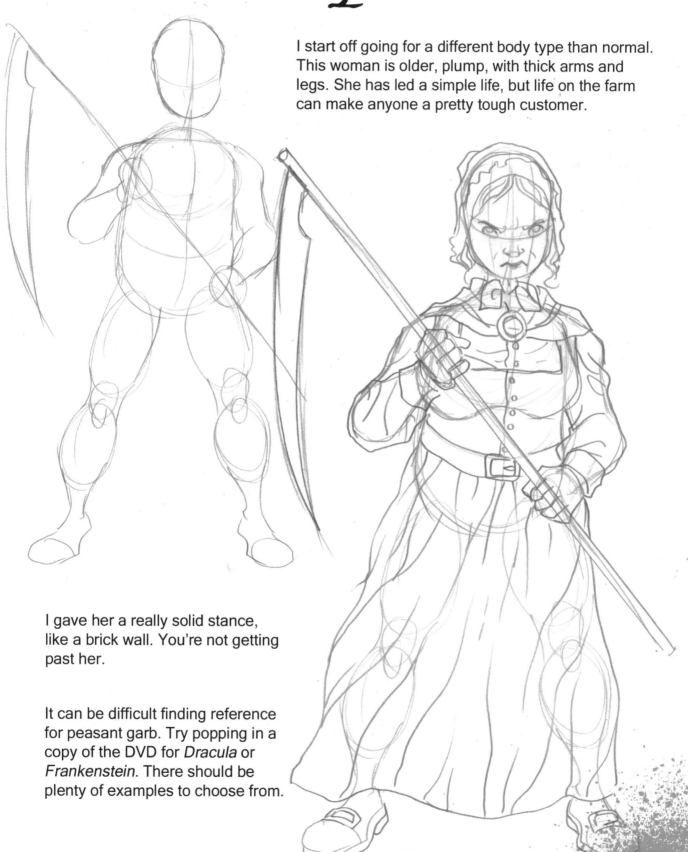

I start off going for a different body type than normal. This woman is older, plump, with thick arms and legs. She has led a simple life, but life on the farm can make anyone a pretty tough customer.

I gave her a really solid stance, like a brick wall. You're not getting past her.

It can be difficult finding reference for peasant garb. Try popping in a copy of the DVD for *Dracula* or *Frankenstein*. There should be plenty of examples to choose from.

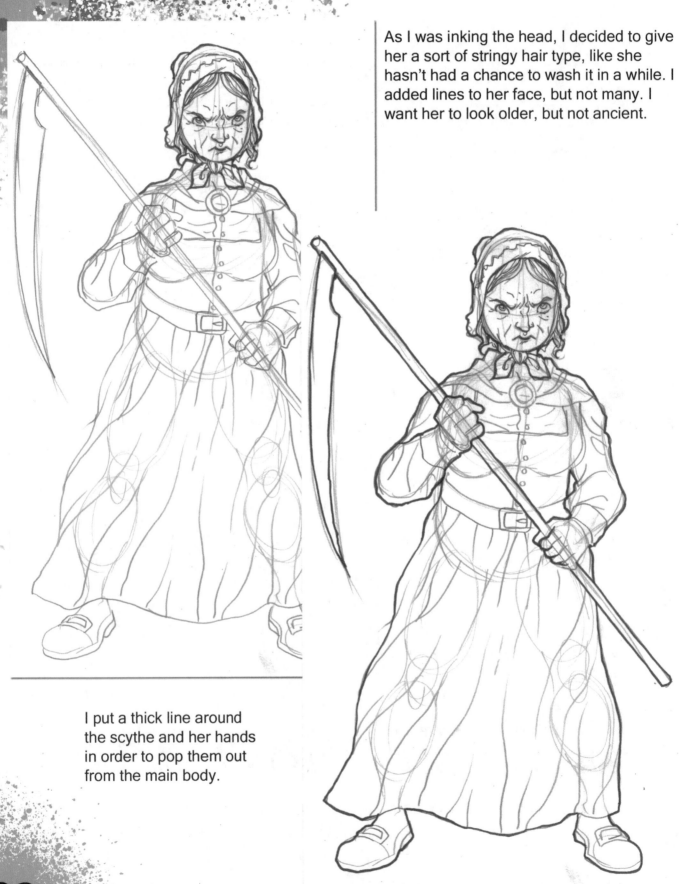

As I was inking the head, I decided to give her a sort of stringy hair type, like she hasn't had a chance to wash it in a while. I added lines to her face, but not many. I want her to look older, but not ancient.

I put a thick line around the scythe and her hands in order to pop them out from the main body.

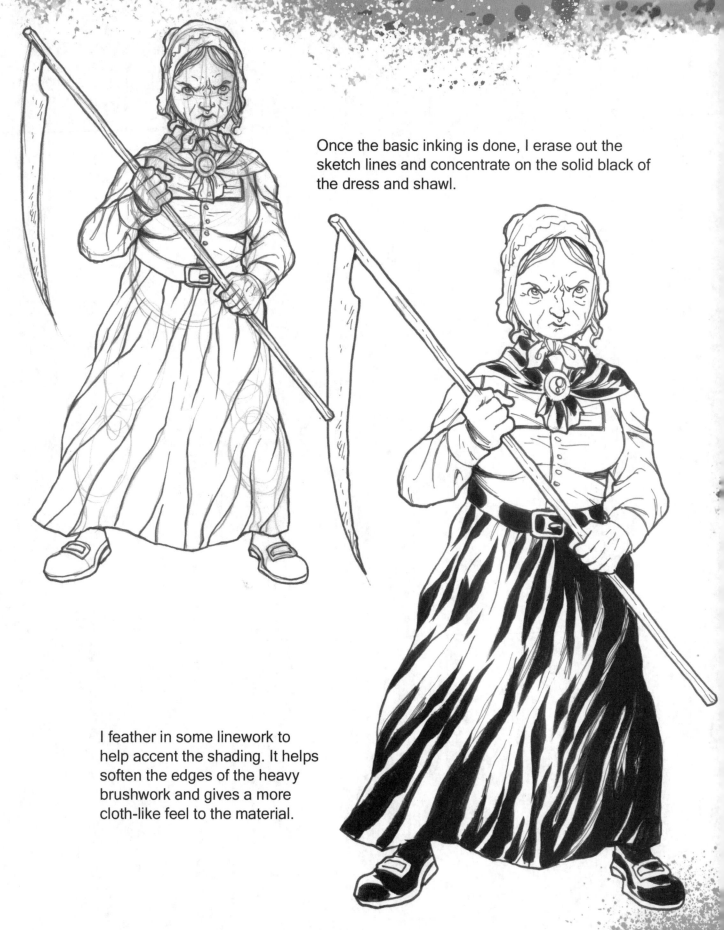

Once the basic inking is done, I erase out the sketch lines and concentrate on the solid black of the dress and shawl.

I feather in some linework to help accent the shading. It helps soften the edges of the heavy brushwork and gives a more cloth-like feel to the material.

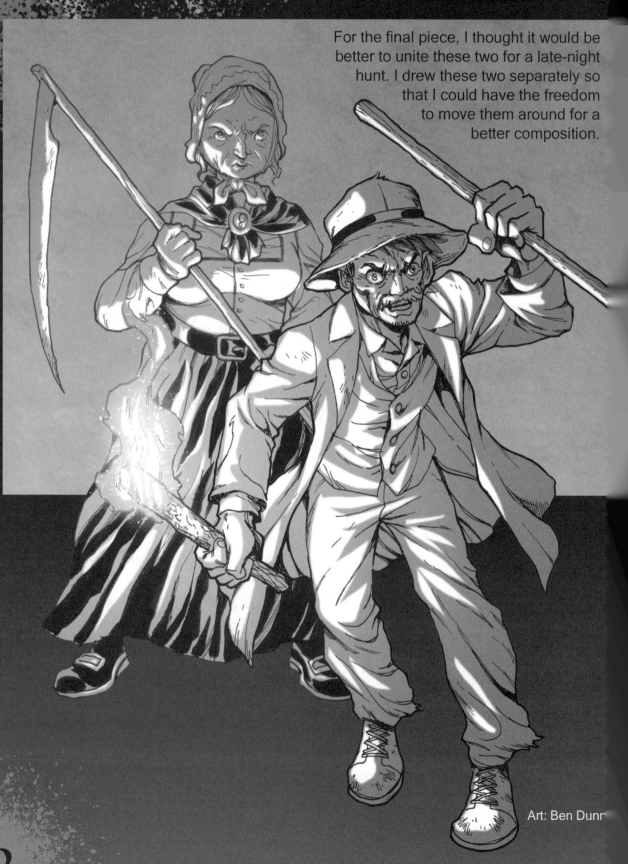

For the final piece, I thought it would be better to unite these two for a late-night hunt. I drew these two separately so that I could have the freedom to move them around for a better composition.

Art: Ben Dunn

MOB

Art: Ben Dunn

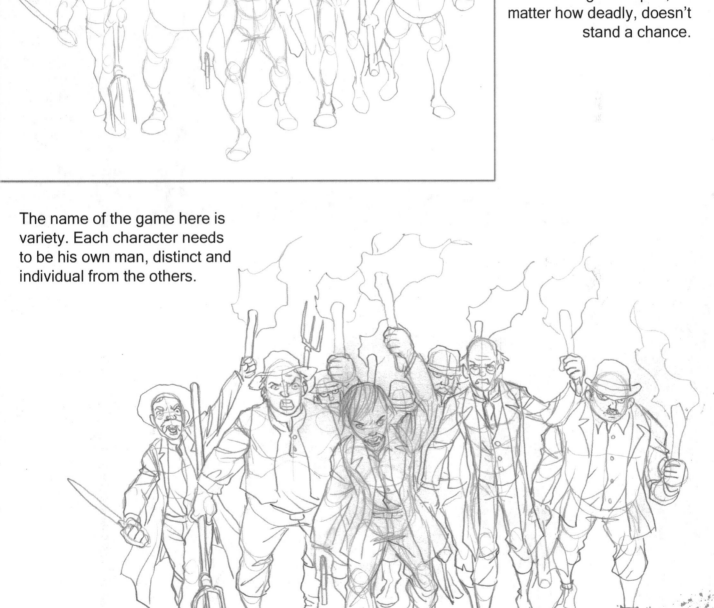

A mob can be a dangerous and powerful enemy. A small army, fueled by hatred, outrage, or fear that can seem more like a force of nature at times. Not much can stand up to mob, and a single vampire, no matter how deadly, doesn't stand a chance.

The name of the game here is variety. Each character needs to be his own man, distinct and individual from the others.

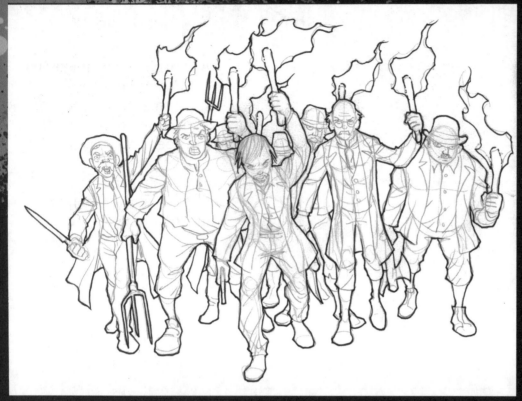

The first step in tackling a mob is to divide and conquer. I give each figure a clear, definite outline to separate it from the others.

When inking a drawing like this, keep in mind that most of the visual density in the art will be up closer to the viewer. The amount of detail will decrease the farther into the distance you go.

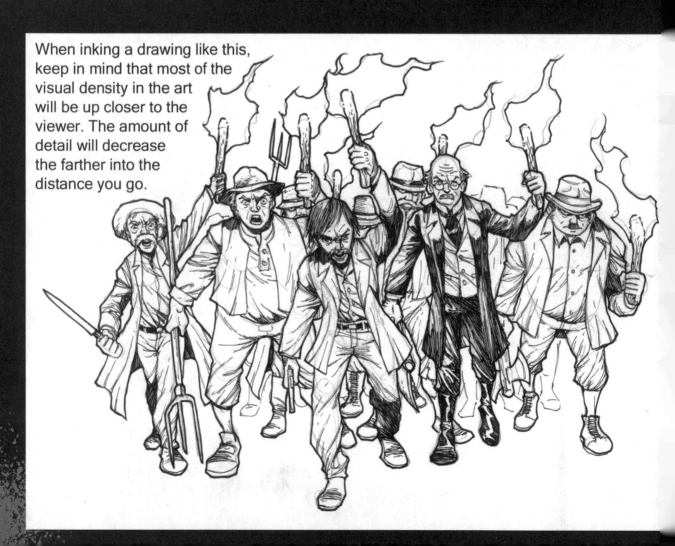

Here are the final tones. I went with a more painterly style for this piece. This is a good subject to help you gain some experiece with multiple character compositions and unusual lighting conditions.

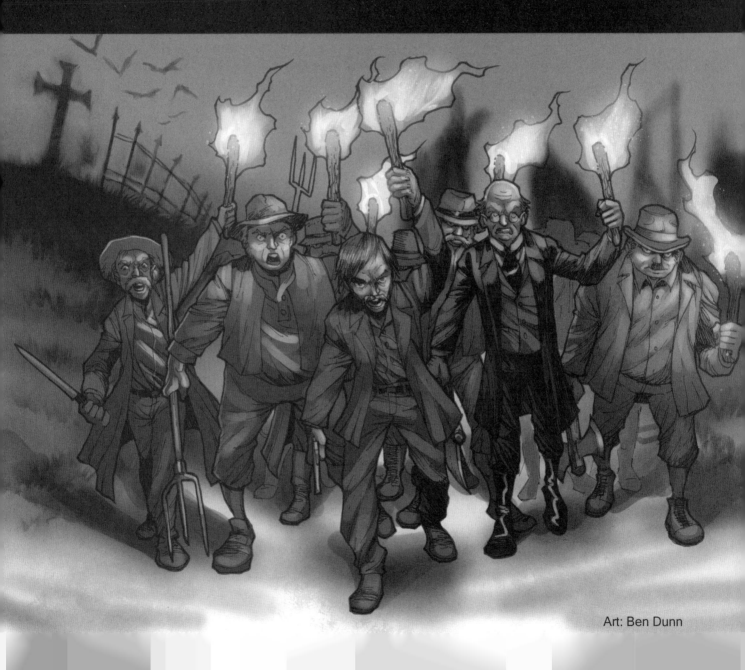

Art: Ben Dunn

ADVENTURER

Art: Ben Dunn

The adventurer is always looking for action. Handsome and daring, he is a risktaker who will never shy away from a challenge.

He is above the average in his experience, talent, and skill. He seems to know a little bit about everything and has survived perils most of us can't even fathom.

I wanted to keep this character out of the typical swashbuckler mold, so I didn't give him a whip or sword. I felt ranged weapons would suit him better and allow him to pick off his undead quarry at a distance.

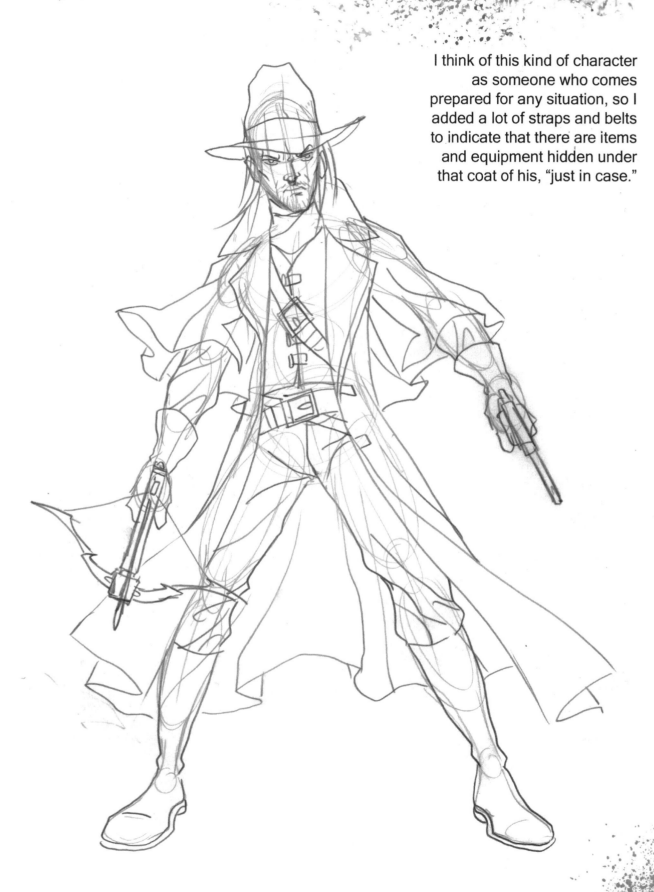

I think of this kind of character as someone who comes prepared for any situation, so I added a lot of straps and belts to indicate that there are items and equipment hidden under that coat of his, "just in case."

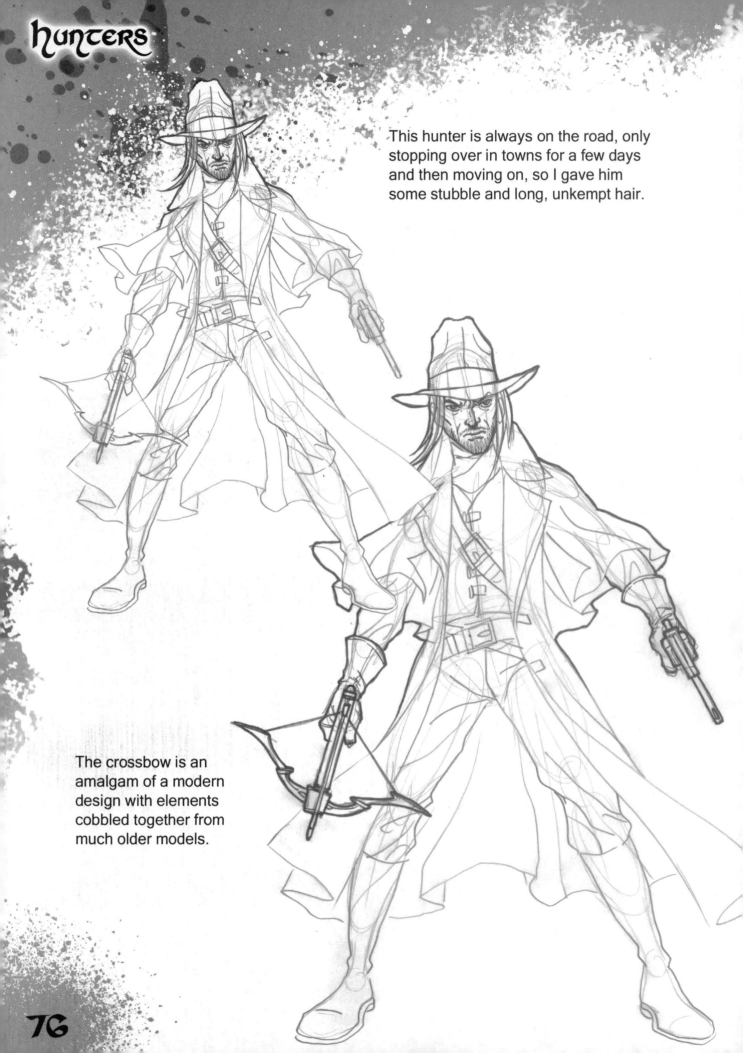

This hunter is always on the road, only stopping over in towns for a few days and then moving on, so I gave him some stubble and long, unkempt hair.

The crossbow is an amalgam of a modern design with elements cobbled together from much older models.

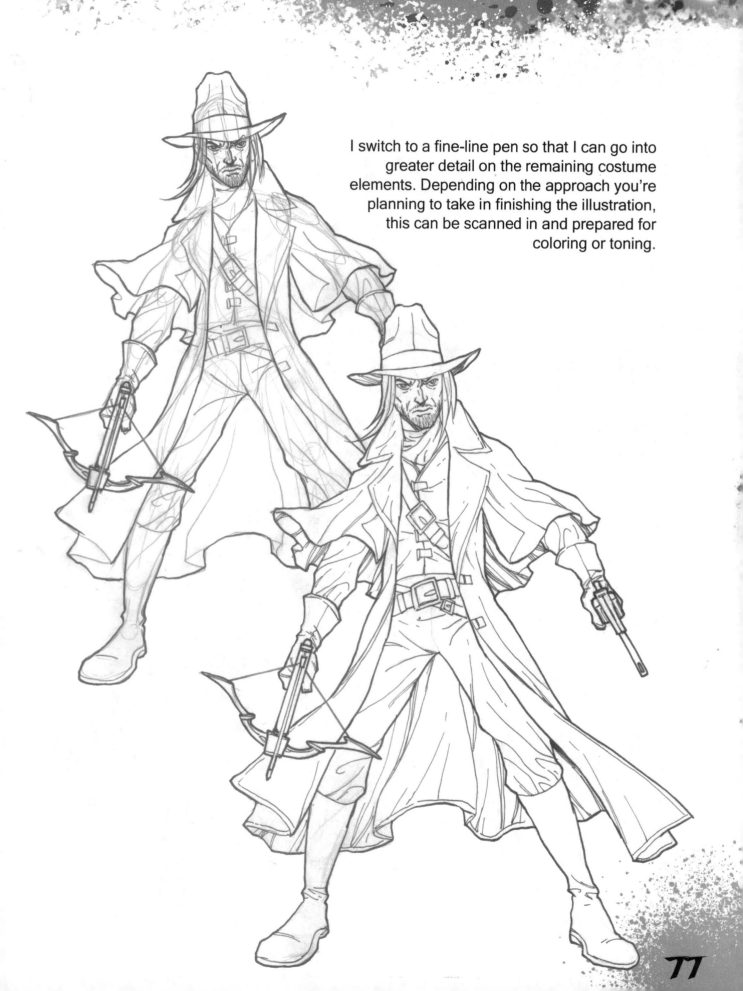

I switch to a fine-line pen so that I can go into greater detail on the remaining costume elements. Depending on the approach you're planning to take in finishing the illustration, this can be scanned in and prepared for coloring or toning.

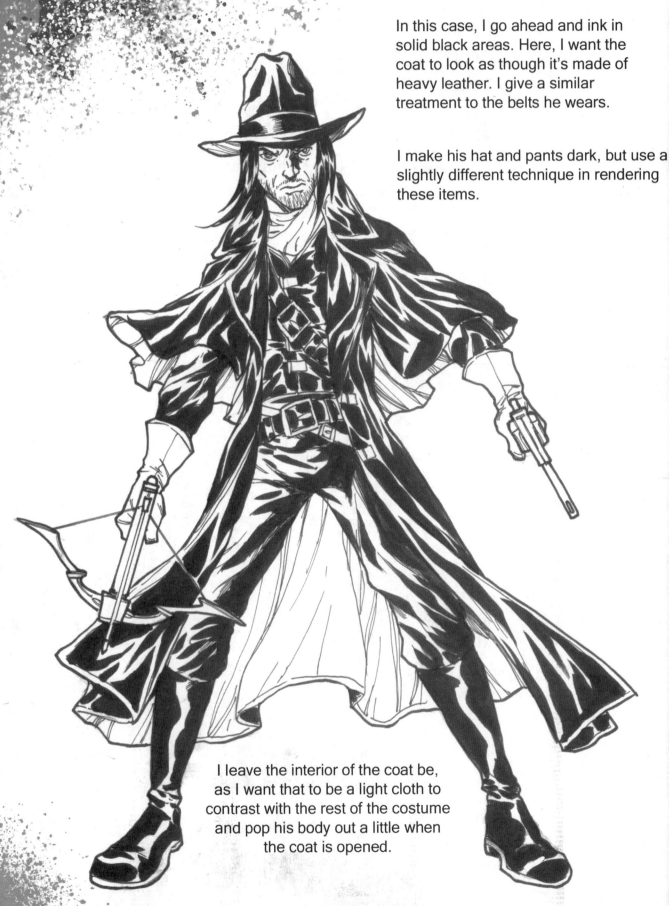

In this case, I go ahead and ink in solid black areas. Here, I want the coat to look as though it's made of heavy leather. I give a similar treatment to the belts he wears.

I make his hat and pants dark, but use a slightly different technique in rendering these items.

I leave the interior of the coat be, as I want that to be a light cloth to contrast with the rest of the costume and pop his body out a little when the coat is opened.

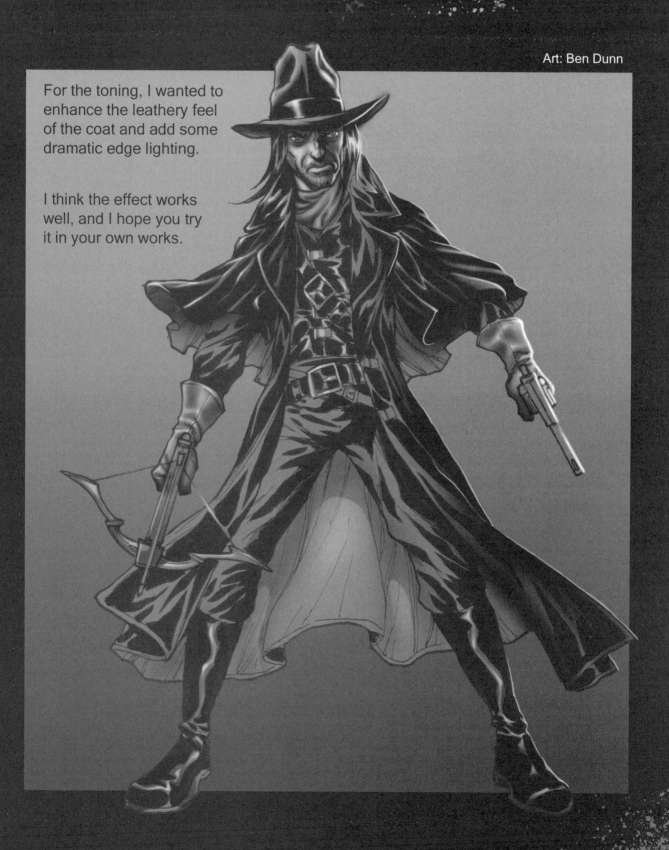

Art: Ben Dunn

For the toning, I wanted to enhance the leathery feel of the coat and add some dramatic edge lighting.

I think the effect works well, and I hope you try it in your own works.

Apprentice

Art: Ben Dunn

Here, we're looking more for a young man, early to mid-teens, not a child. The apprentice needs to be pretty strong, as he will be as much a pack mule as he will be an assistant.

Our apprentice is carrying food, bedding, and tools for opening crypts and coffins. He has many of the weapons and items to ward off vampires, and provides an extra pair of hands, so in many ways, he's an essential part of the team!

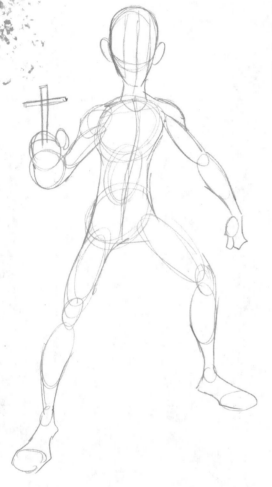

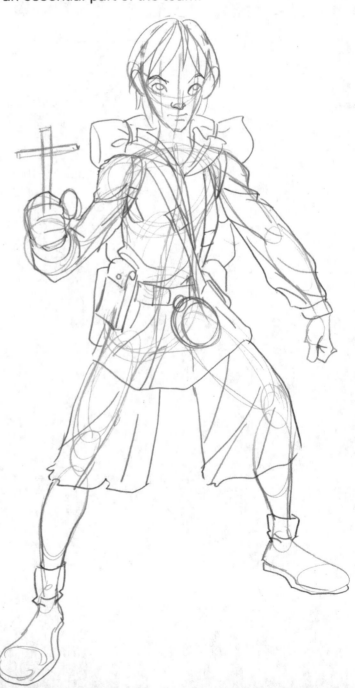

The great thing about a character like this is the fact that, with a few minor changes to his garb, he would fit in almost anywhere, at any time period.

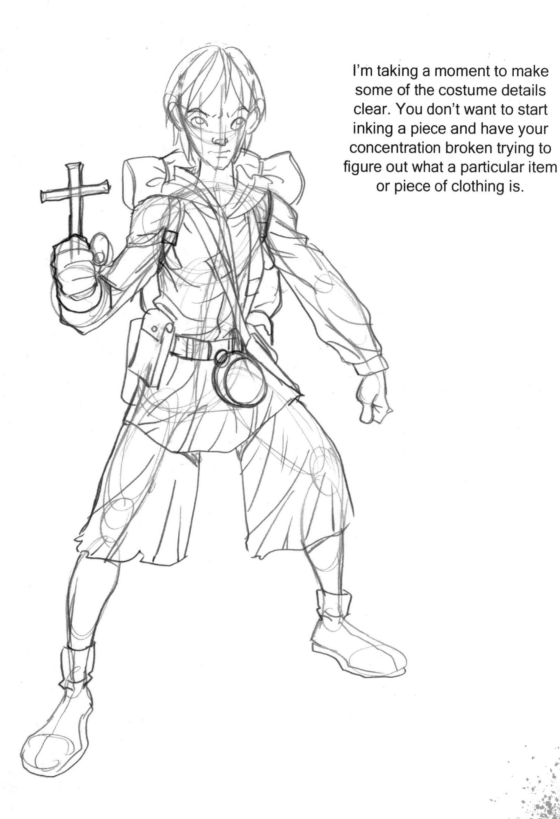

I'm taking a moment to make some of the costume details clear. You don't want to start inking a piece and have your concentration broken trying to figure out what a particular item or piece of clothing is.

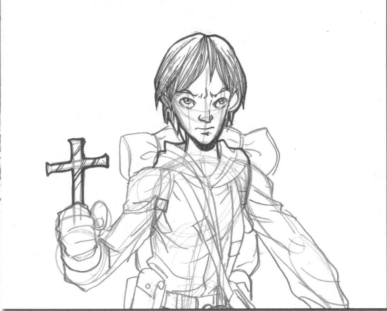

As I ink the head, I'm trying to straddle the line between youth and maturity. I maintain the larger eyes we generally see in young children, but give him a nose closer to what an adult might have. He has a longer face than that of someone younger, but his jaw is still small and underdeveloped.

I outline the figure, and I make his clothes a little raggedy at the ends. Maybe this character comes from some humble beginnings, or is wearing clothing handed down to him from an older sibling.

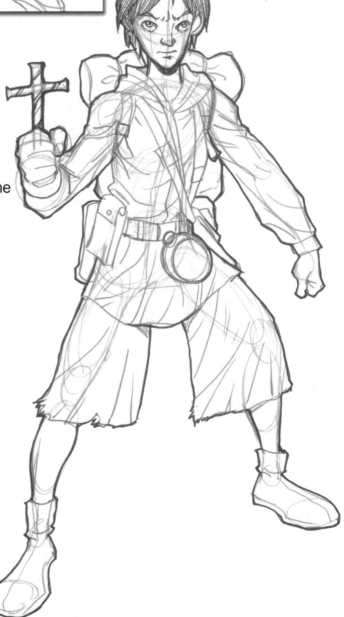

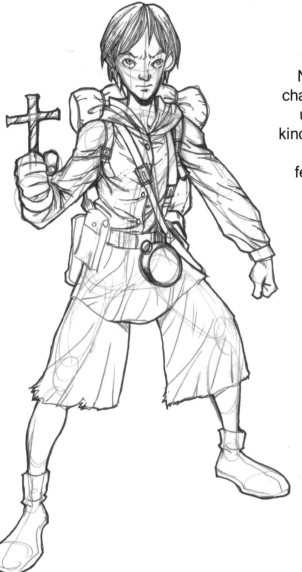

Now we can begin detailing the rest of the drawing. Our character is clad in practical, tough materials that will hold up for a long time under use. Try to imagine what those kinds of fabric feel like, and try to convey that on the page. Often, it's more effective to try and communicate the feeling of a texture than to reference a photograph for it.

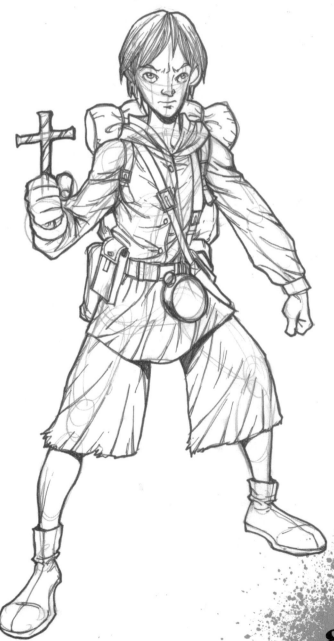

The inking seems to be working. Now to erase and add the finishing details.

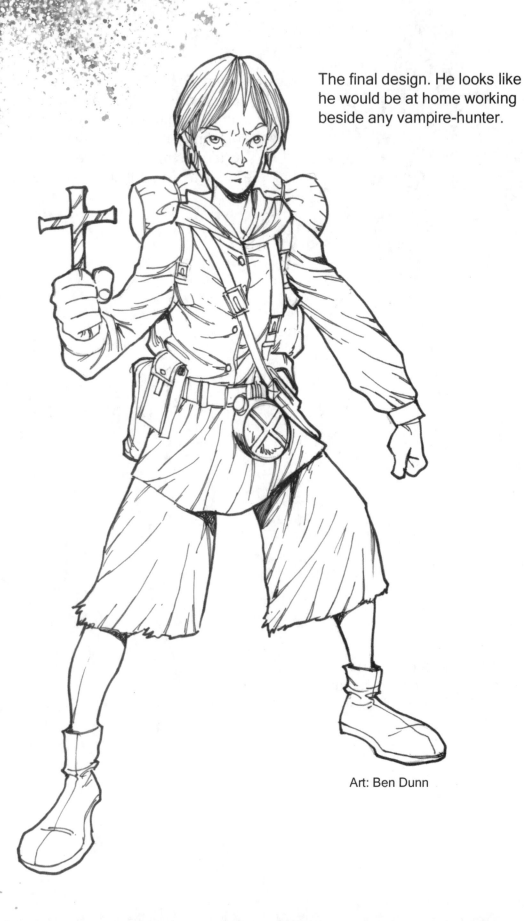

The final design. He looks like he would be at home working beside any vampire-hunter.

Art: Ben Dunn

Priest

Art: Ben Dunn

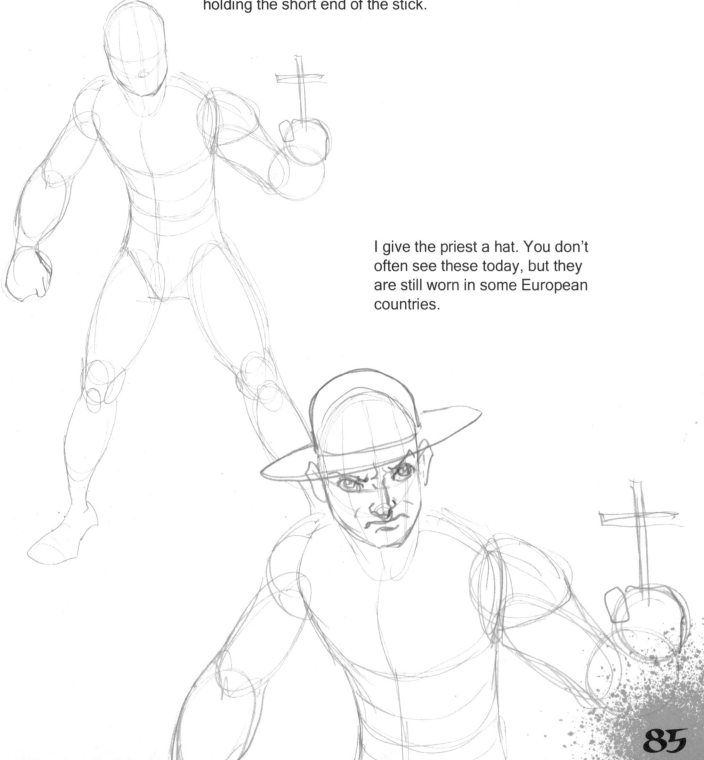

Is there any better weapon against the forces of Darkness than simple faith? Is there anyone more prepared to battle those forces than a priest? No matter how long-lived a vampire may be, sooner or later, he's going to come face to face with a priest, and the vampire may just find himself holding the short end of the stick.

I give the priest a hat. You don't often see these today, but they are still worn in some European countries.

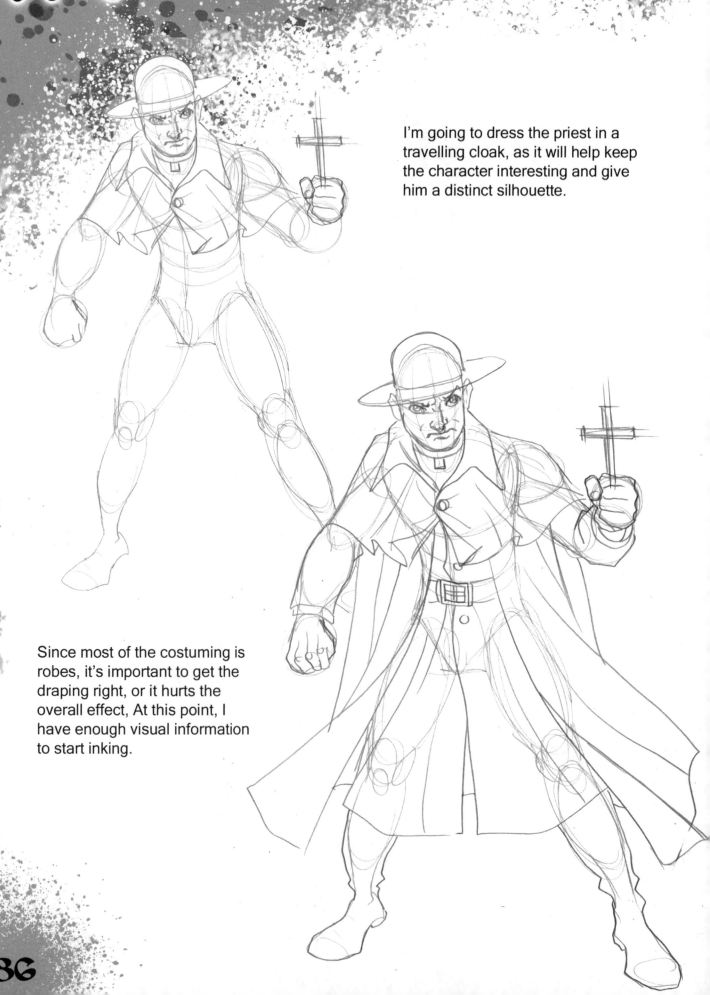

I'm going to dress the priest in a travelling cloak, as it will help keep the character interesting and give him a distinct silhouette.

Since most of the costuming is robes, it's important to get the draping right, or it hurts the overall effect, At this point, I have enough visual information to start inking.

When I inked the face, I tried to keep the priest expression more determined or grim, rather than angry or furious.

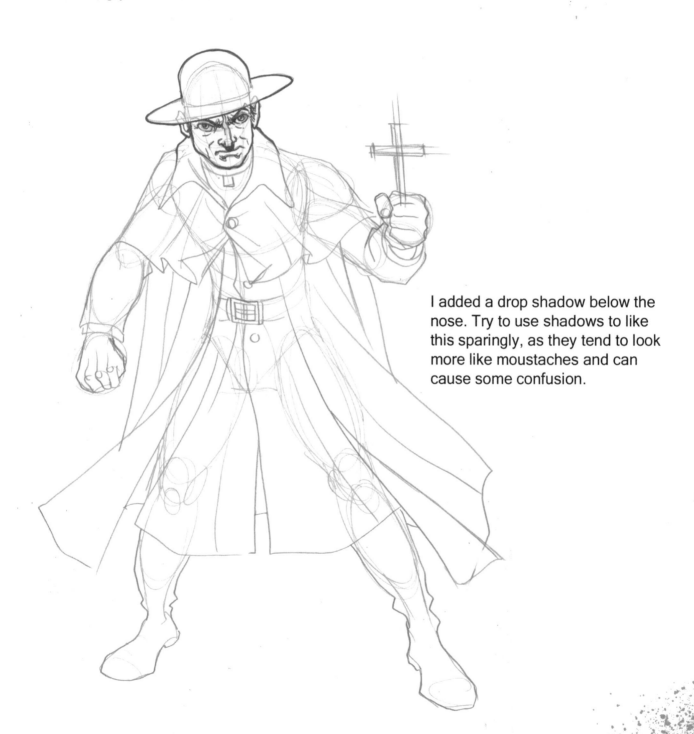

I added a drop shadow below the nose. Try to use shadows to like this sparingly, as they tend to look more like moustaches and can cause some confusion.

Outlining the figure is straight-
forward enough. As I go about
inking the lines, I'm planning out
how I want to render the
costume and making mental
notes of what needs to be
improved in the final inks.

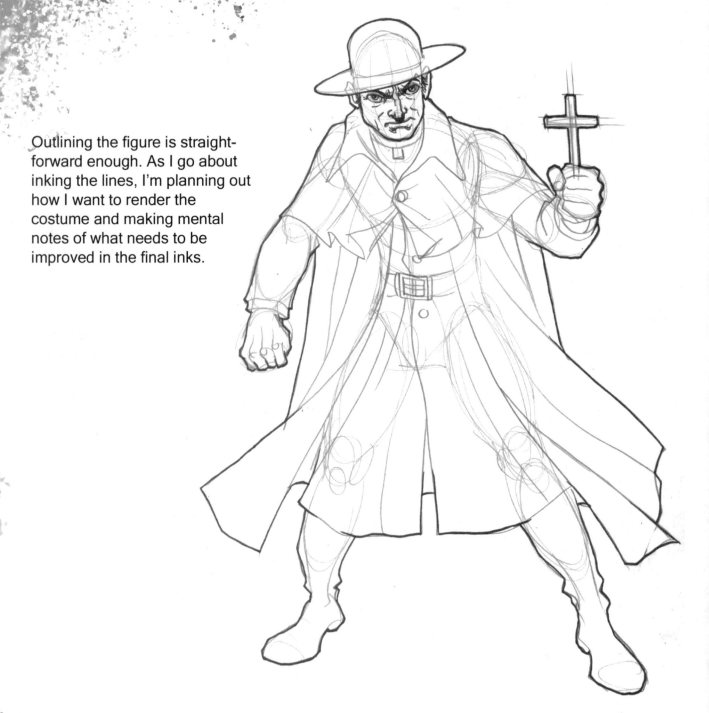

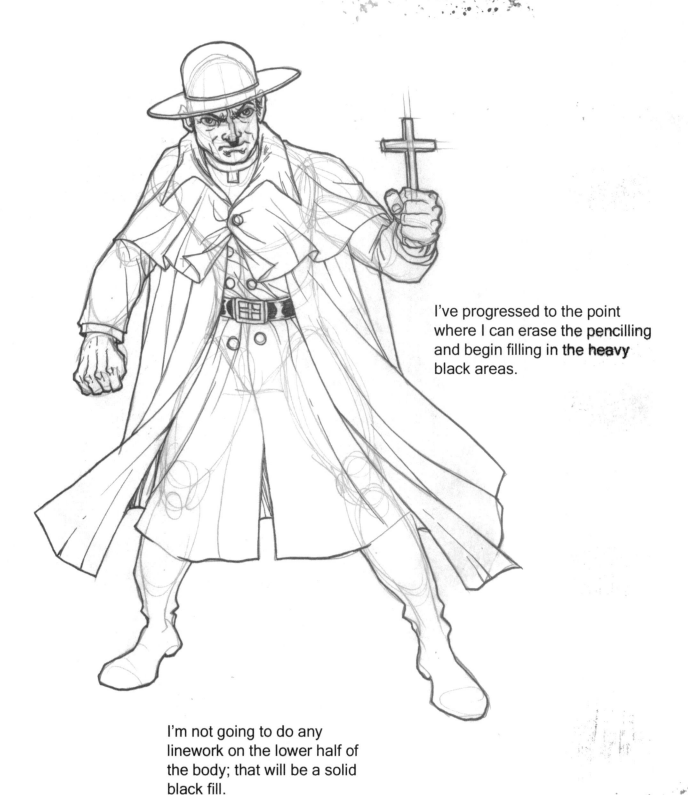

I've progressed to the point where I can erase the pencilling and begin filling in the heavy black areas.

I'm not going to do any linework on the lower half of the body; that will be a solid black fill.

As I start laying down the final inks, I decide I'm going to have to give the clothing a bit of a sheen. In real life, it wouldn't have the high contrast that I'm giving it here, but I need this to keep the drawing interesting and alive.

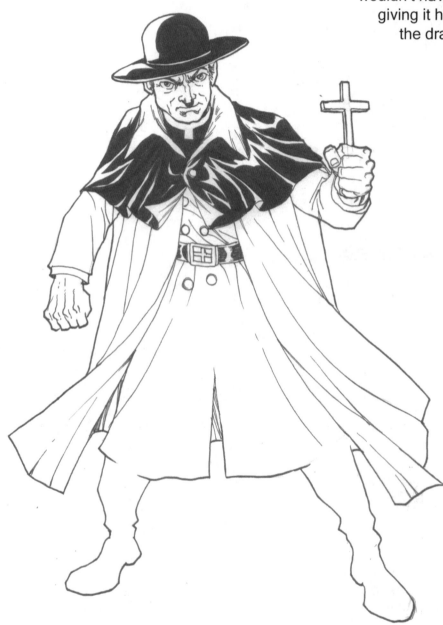

The final piece. As I said earlier, I've kept the lower half of the body completely in shadow. This keeps most of the visual interest up near the head and hands, where most of the action is taking place.

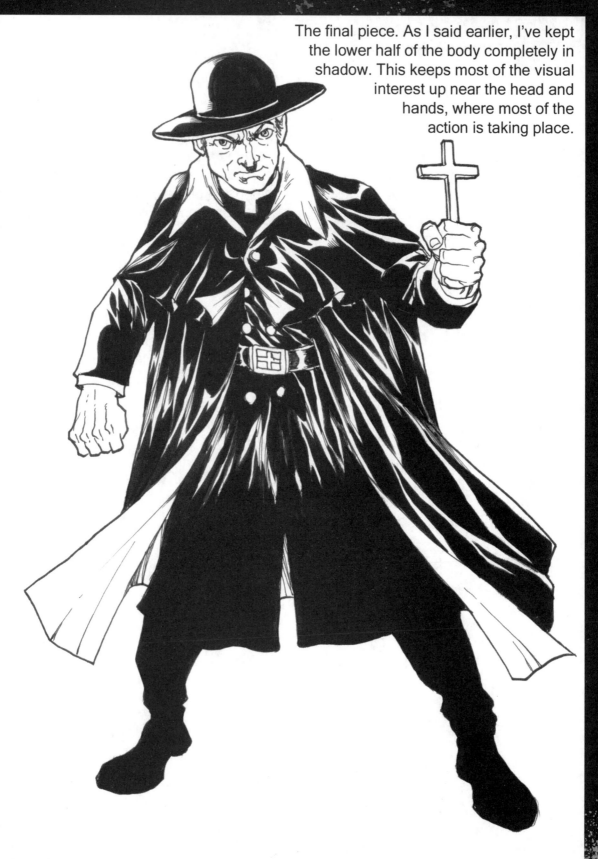

Art: Ben Dunn

PROFESSOR

Art: Ben Dunn

While not a hunter in the sense that he goes to grave-yards and drives wooden stakes home, the professor can prove himself a deadly enemy to a vampire.

He has a keen interest in and deep knowledge of a wide variety of occult subjects. Not only does he know to dispatch even the most obscure breed of bloodsucker, he could tell you the vampire's birth name and provide a history of the creature's crimes against the living.

I begin by giving the character some of the classic trappings of tenured life: large, thick glasses, a pipe, and a tome of vampire lore.

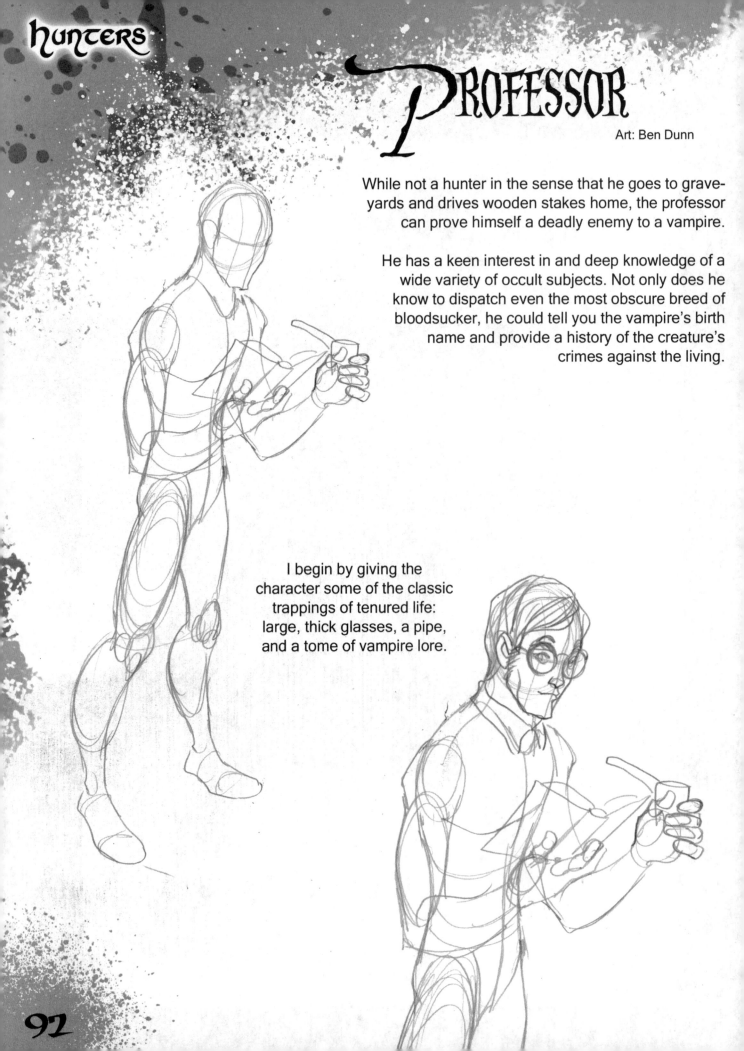

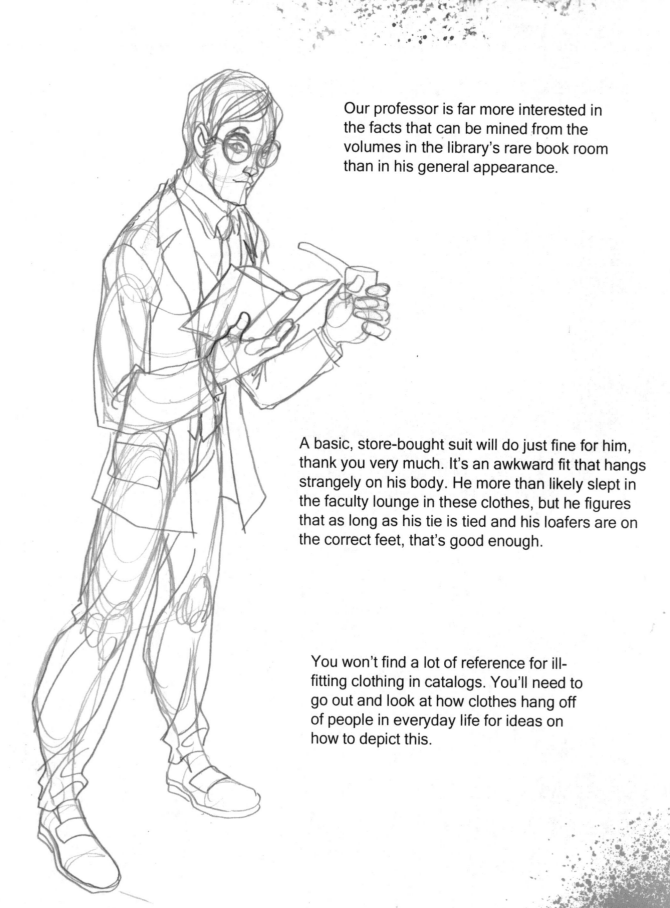

Our professor is far more interested in the facts that can be mined from the volumes in the library's rare book room than in his general appearance.

A basic, store-bought suit will do just fine for him, thank you very much. It's an awkward fit that hangs strangely on his body. He more than likely slept in the faculty lounge in these clothes, but he figures that as long as his tie is tied and his loafers are on the correct feet, that's good enough.

You won't find a lot of reference for ill-fitting clothing in catalogs. You'll need to go out and look at how clothes hang off of people in everyday life for ideas on how to depict this.

I'm not going for a specific time period here; the professor could fit in almost any modern setting. The sideburns seem to indicate that he's most likely from an earlier era, but maybe he's just trying to be "hip".

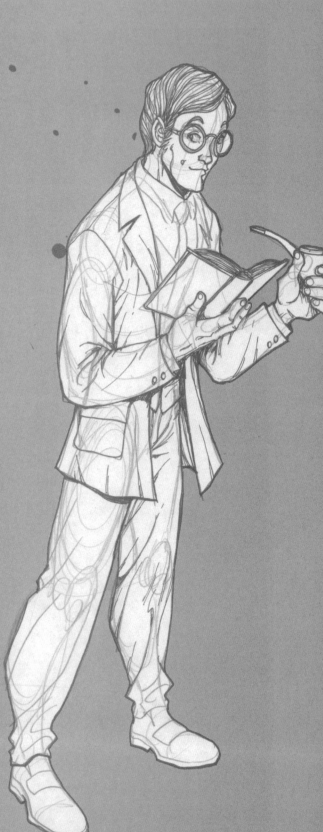

The type of pants he's wearing feel more modern. It's kind of unusual to find pants with no cuffs on a professional. The shoes are classic loafers, for the busy vampire hunter on the go.

Final inks. I altered the character's expression slightly from the initial sketch. He seemed a little smug or condescending, and I wanted him to be more approachable.

Textures throughout are meant to show the age of the garments, rather than extreme use. With a professor's salary, you might only have one or two good suits.

This is his good suit.

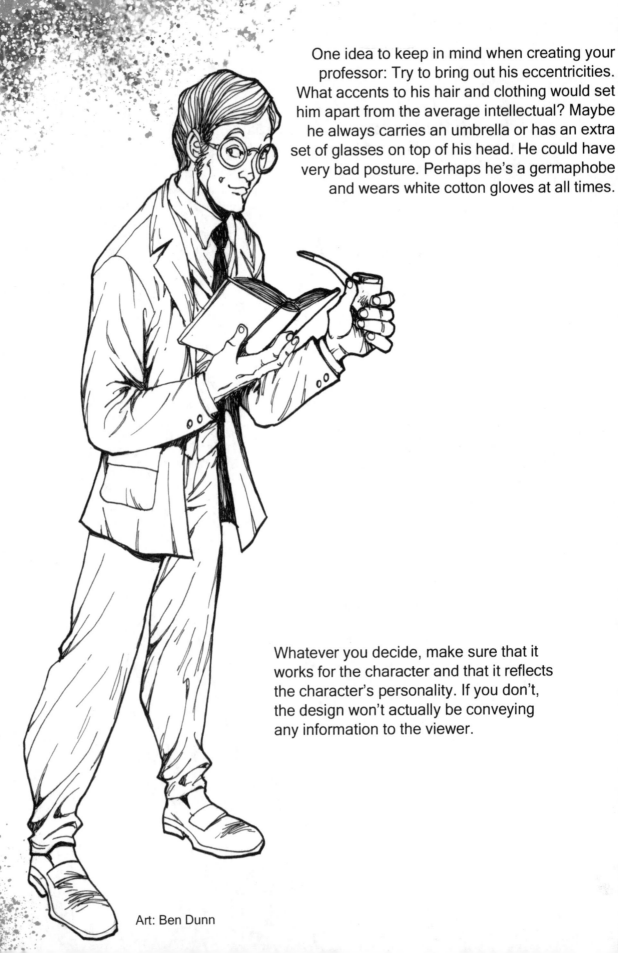

One idea to keep in mind when creating your professor: Try to bring out his eccentricities. What accents to his hair and clothing would set him apart from the average intellectual? Maybe he always carries an umbrella or has an extra set of glasses on top of his head. He could have very bad posture. Perhaps he's a germaphobe and wears white cotton gloves at all times.

Whatever you decide, make sure that it works for the character and that it reflects the character's personality. If you don't, the design won't actually be conveying any information to the viewer.

Art: Ben Dunn

Village

Art: Ben Dunn

Welcome to the village.

You're looking at the perfect hunting ground for vampires: an isolated town with one road, a small population, and any number of places to hide during the day.

Depicting a location like this can be time-consuming and confusing for the artist. While the forms involved are simple, the perspectives are a little more advanced. Nearly every building has its own vanishing point, and maintaining proper scale can be difficult to accomplish without a human scale reference.

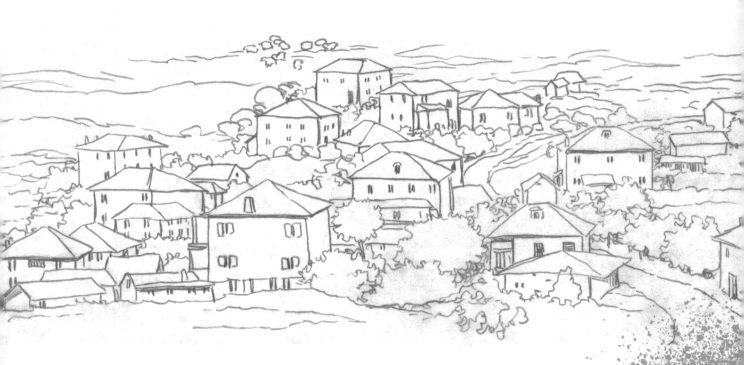

Graveyard

Some vampires don't have the luxury of secreting themselves away in a family crypt under their own private castle. While they find churches and other holy places repellent, they will hide in such places. Certain types of vampires will enter graveyards to feed on the flesh of the recently buried.

A crumbling, dilapidated structure like this can be achieved with a basic freehand perspective drawing. Finishing the illustration with a ruler can ruin the organic feel of a structure that is falling apart.

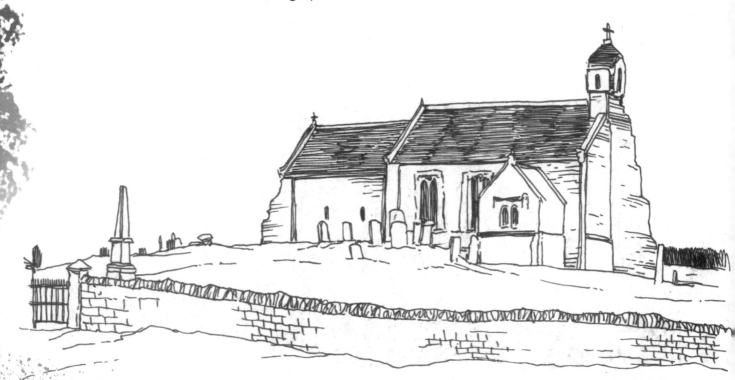

Art: Ben Dunn

FARMLAND

Art: Ben Dunn

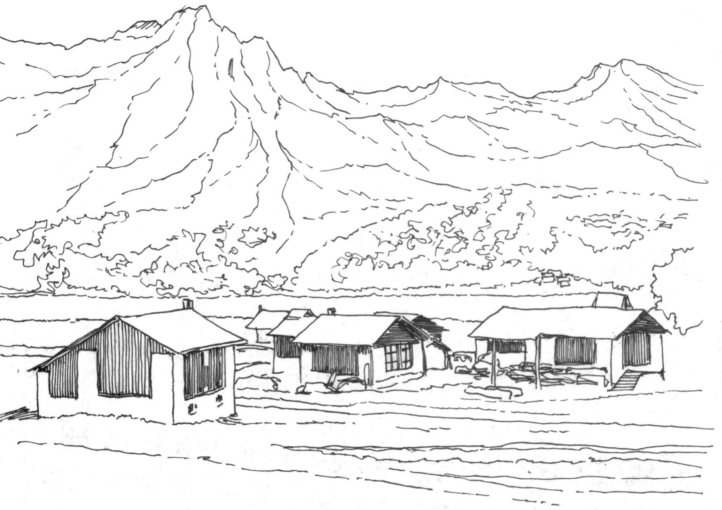

Small farming communities like this are at the absolute mercy of a vampire. They usually have no church or priest of their own and have little contact with the rest of the world, save for at harvest time. With a composition like this, with that mountain range in the background and these small, exposed huts out in the open, I want you to feel like these people are backed against a wall, with no avenue of escape.

COFFINS

Art: Ben Dunn

The coffin is an indispensable asset to any vampire. It offers the vampire protection from both exposure to the elements and vulnerablity to hunters looking to profit from a vampire's beauty sleep.

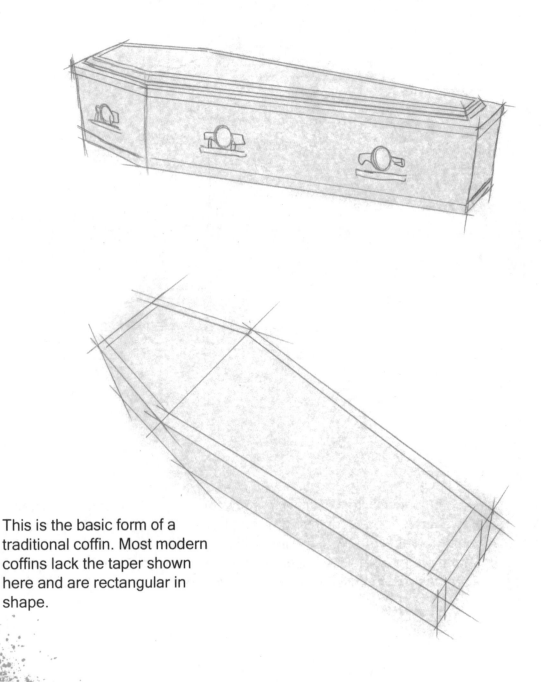

This is the basic form of a traditional coffin. Most modern coffins lack the taper shown here and are rectangular in shape.

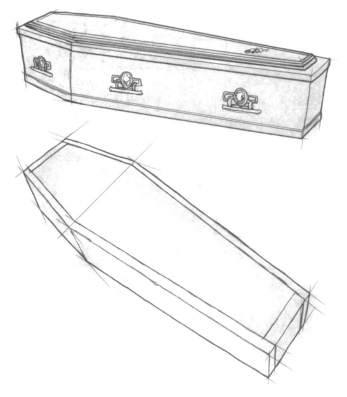

The coffin at the top is a high-end model featuring metal fixtures and some molding. An older model might feature a family coat of arms.

These coffins have similar shapes, but with a simple use of different textures and visual elements, the one at the top looks almost sleek in comparison to the rough-hewn wooden coffin.

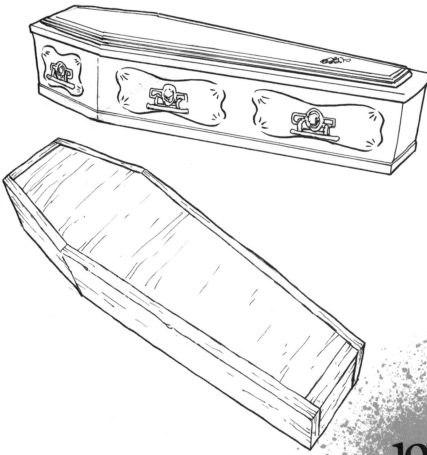

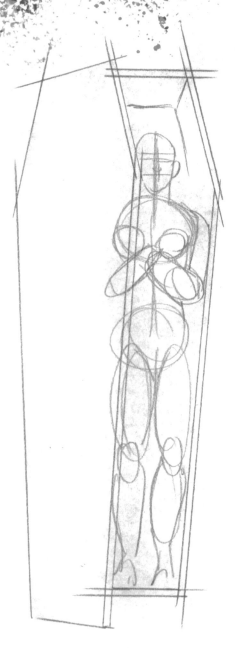

It goes without saying that you don't want to be in the room if one of these caskets opens on its own, but here is what we might see if we were.

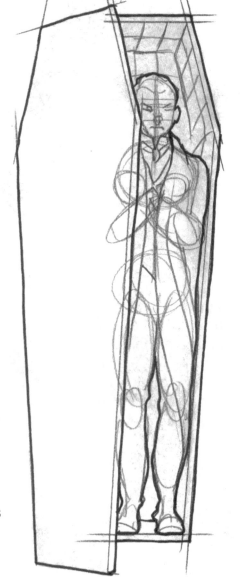

In this case, I'm going to draw the coffin first and place the character inside. This way, the coffin will be a better fit to the character, and the vampire's interaction with his surroundings will be more convincing.

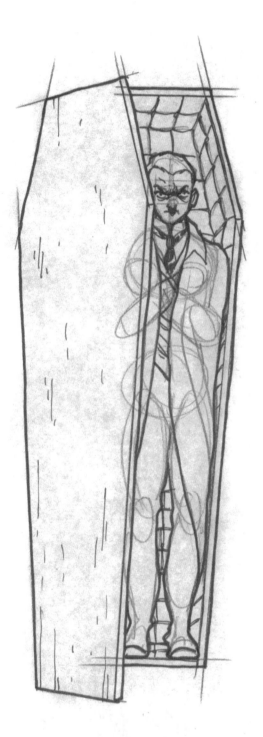

This vampire is cunning! No one would go looking for a member of his caste in some crude pine box meant for a potter's field.

But in reality, our fanged friend is in the lap of luxury here! A cushioned velvet lining and some amenities we can't see make this the perfect resting place for a weary vampire.

For the background of this piece, I photographed a concrete sidewalk and rocks outside of the studio. I composited these into the picture and added some brush textures and a little linework to complete the effect of some dark, dank crypt.

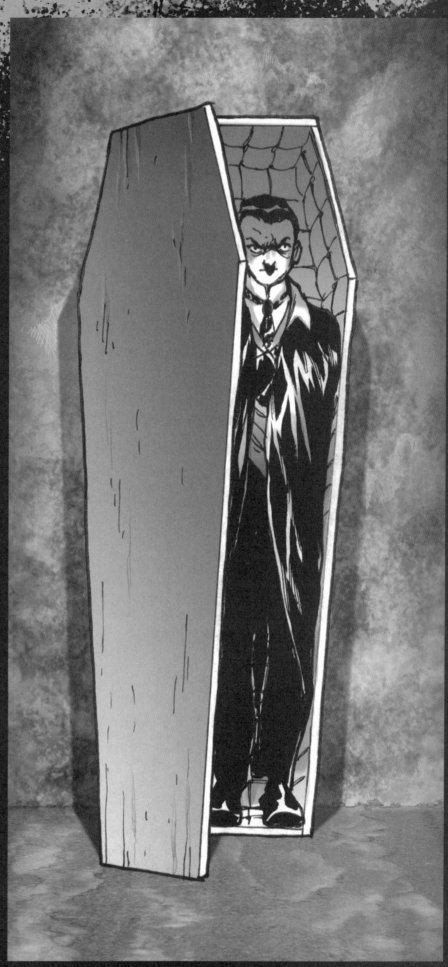

Art: Ben Dunn

Fire

Art: Ben Dunn

Fire is an invaluable tool to the hunter. It provides light in the dark, nearly inaccessible places they need to go, as well as a heat source for staying warm, and, of course, for cooking food.

It's most useful to the hunter for destroying vampires, who go up like dry brush on contact with flame. The older the vampire, the faster and more thorough the fire will be.

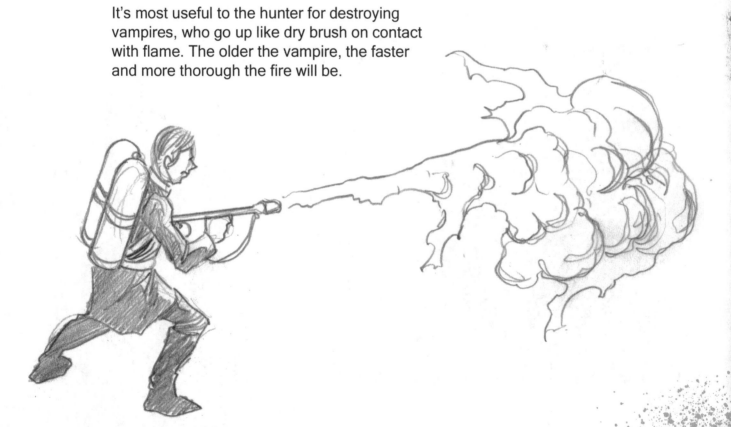

Mirror

Art: David Hutchison

Vampires hate mirrors. Hunters love them. Mirrors always betray the true nature of the creature, who may have been working hard to blend into the local community while looking for prey. At one time, silver was a component in the backing of mirrors, and perhaps some quality of this pure metal was involved.

Again, mirrors are often basic shapes: squares, ovals, or circular—whatever you want to use. Size should depend on the situation. Anything from a makeup mirror to the ceiling mirror in a hotel room will do.

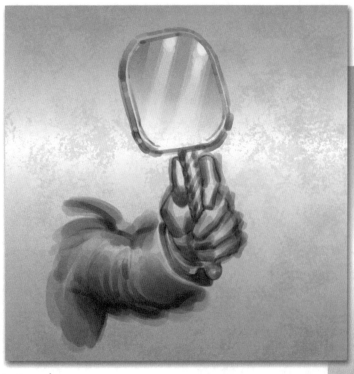

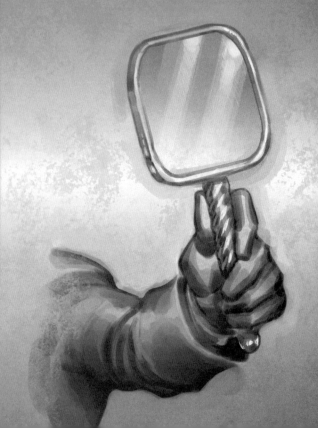

GARLIC

Vampires have an instinctual dislike for garlic and give it as wide a berth as possible. Even a faint odor of garlic is enough to sicken a vampire.

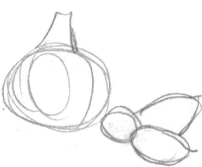

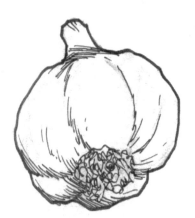

While people have been known to string up garlic near the doors and windows of their homes, this is not guaranteed to work. Vampires sometimes have human agents that will dispose of such wards for their masters.

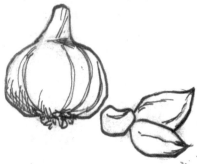

Art: Ben Dunn

HAMMER & STAKE

Art: Ben Dunn

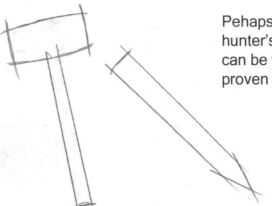

Pehaps the most famous and most used of the tools at a hunter's disposal are the hammer and stake. These tools can be found or fashioned almost anywhere and have proven the undoing of an untold number of the undead.

A hammer and stake are very basic, simple shapes. While they can be very elaborate for a very stylized image, it's rarely necessary to go that far.

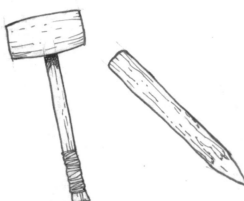

The real challenge is in properly showing a hand holding these items. Photograph yourself or a friend for reference so that you can do it right.

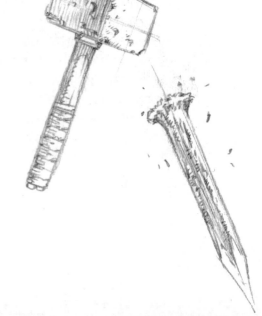

HOLY WATER

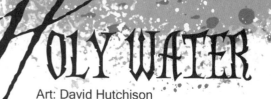

Art: David Hutchison

If you ever want a vampire to show real fear, just reach for a bottle of holy water. Fire or sunlight can hurt or destroy a vampire, but holy water destroys the evil. There's no return for a vampire whose ashes have been purified with it.

I start out with a basic cylinder for the bottle. For the water inside, I keep the surface level with the viewer, as if the bottle has been tilted in our direction.

The most difficult part is in showing a clear substance inside of a clear container. I shade in the areas around the form the water is meant to take in order to help separate it from the glass surrounding it.

TOOLS

I strengthen the outline around the bottle with a black line.

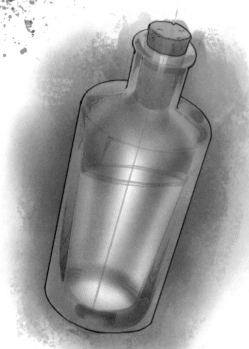

As I go in and add the highlights, I decide that a white outline would serve better and change the outline accordingly.

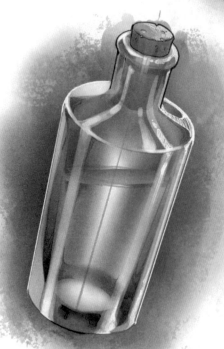

The final step involves adding reflective highlights to the surface of the water and adding a cross to the outside of the bottle.

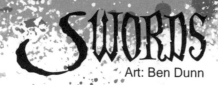

SWORDS

Art: Ben Dunn

Swords can be very handy weapons in a pinch. The real problem with them is that they can be used by human and vampire alike, and often vampires have far more experience with them than any human. Additionally, vampires suffer far less from this weapon than just about anything else in a hunter's arsenal.

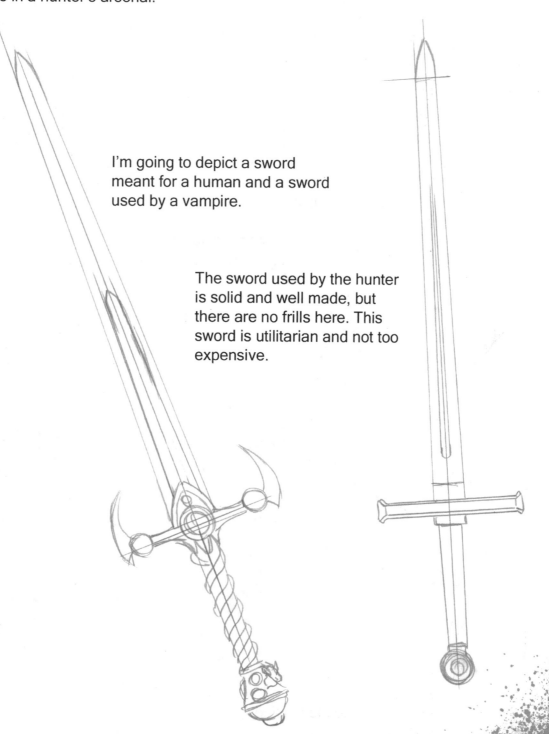

I'm going to depict a sword meant for a human and a sword used by a vampire.

The sword used by the hunter is solid and well made, but there are no frills here. This sword is utilitarian and not too expensive.

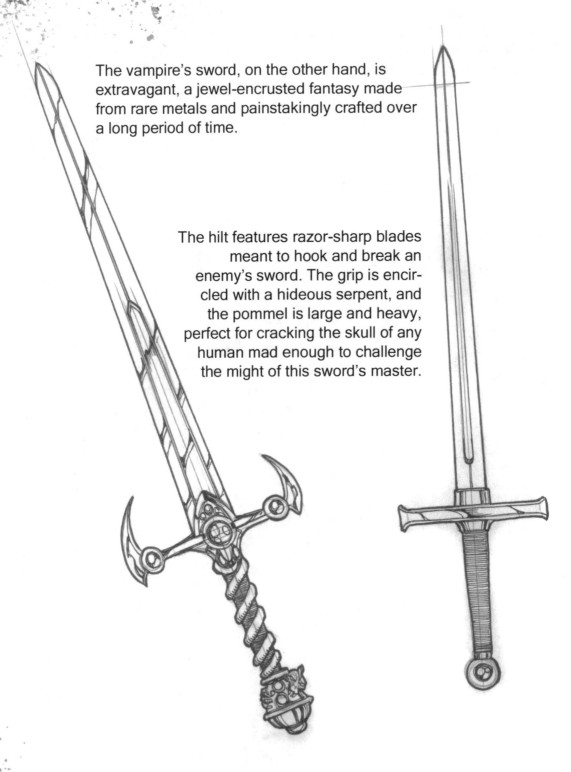

The vampire's sword, on the other hand, is extravagant, a jewel-encrusted fantasy made from rare metals and painstakingly crafted over a long period of time.

The hilt features razor-sharp blades meant to hook and break an enemy's sword. The grip is encircled with a hideous serpent, and the pommel is large and heavy, perfect for cracking the skull of any human mad enough to challenge the might of this sword's master.

Art: Ben Dunn

The cleaned-up inks. There are any number of sword designs. The two shown here are presented to give you a general idea of what's possible. Hopefully, these will kick-start your imagination and get you going in the right direction.

TORCHES

Art: Ben Dunn

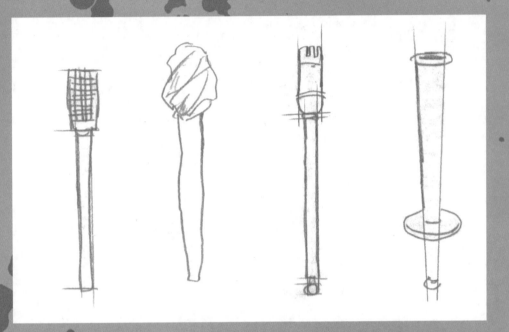

Used around the globe for centuries, torches were the constant companions of vampire hunters the world over until the advent of the flashlight. Modern-day hunters still use them in a pinch, and they can be made from materials at hand. There are any number of different types your hunter could make or buy.

Torches are typically fueled by oil, animal fat, or certain types of plant resin. Do some research, as the fuel sometimes dictates the design of the torch.

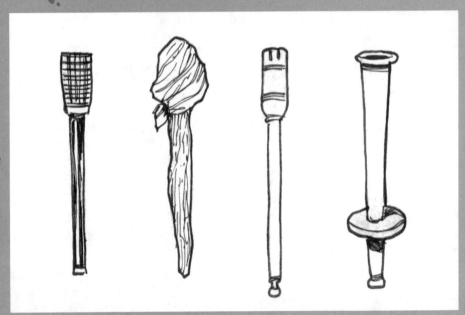

SHOVEL

Art: David Hutchison

A trick vampires sometimes use is to bury themselves in a fresh grave. They can come and go as they please, and the disturbed earth is never questioned. Hunters err on the side of caution and always carry a shovel in case the vampire is suspected of going to ground, literally.

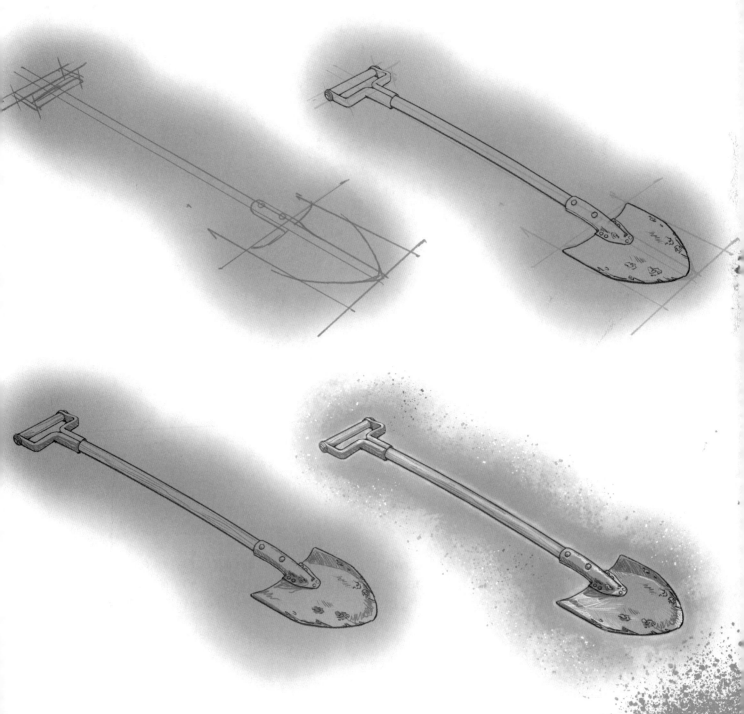

DECAPITATION

Art: David Hutchison

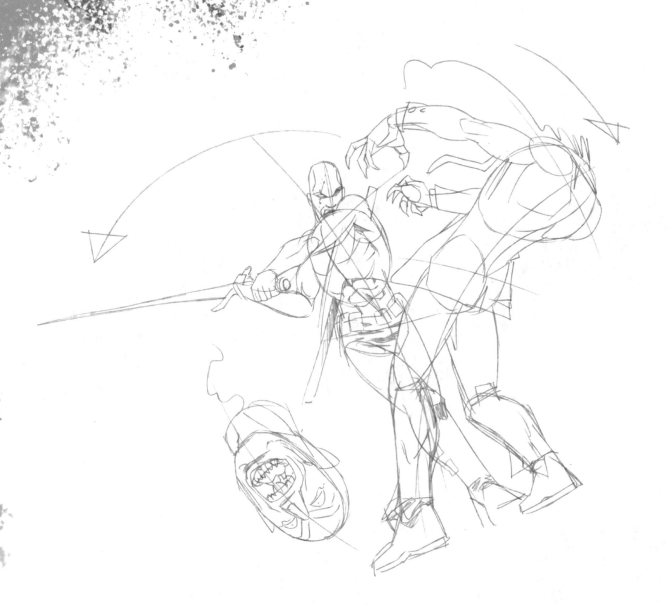

The quickest way to cut a vampire down to size is by decapitating it. I want a lot of motion in this piece, so I really torque the upper body of the hunter as he follows through on his swing. I send the body of the vampire reeling backward from the blow, like a puppet whose strings have been snipped.

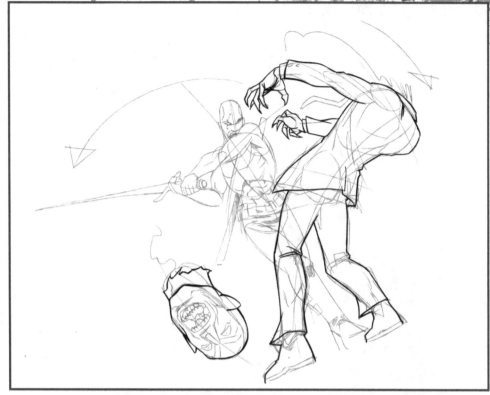

I'm going to tackle this piece by working front to back. I start by inking the outlines of the severed head and the vampire's body.

Now I ink the interior details of the vampire's head.

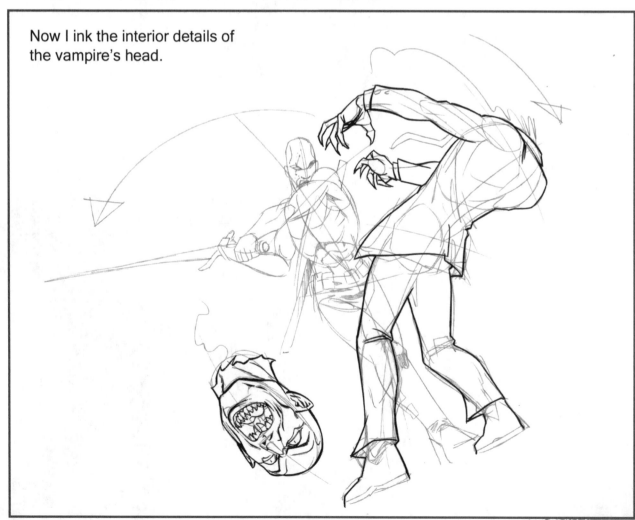

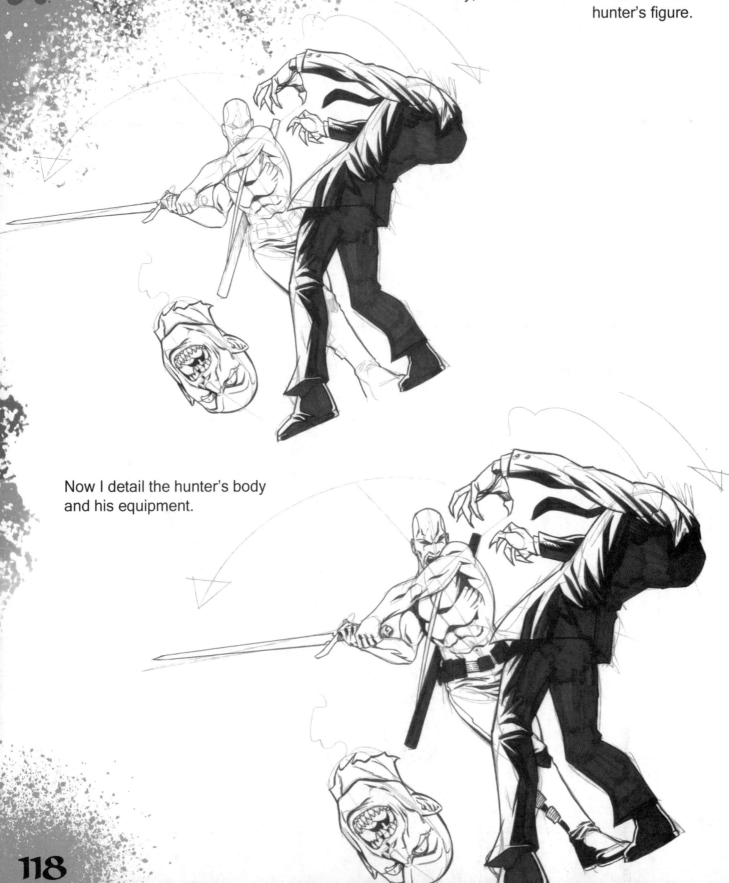

Once I'm done inking in the vampire's body, I start work on the outline of the hunter's figure.

Now I detail the hunter's body and his equipment.

After I've finished inking, I scan the image in and start the toning. I shaded the figures and then added a secondary, lighter shade to indicate reflected light bouncing from the floor.

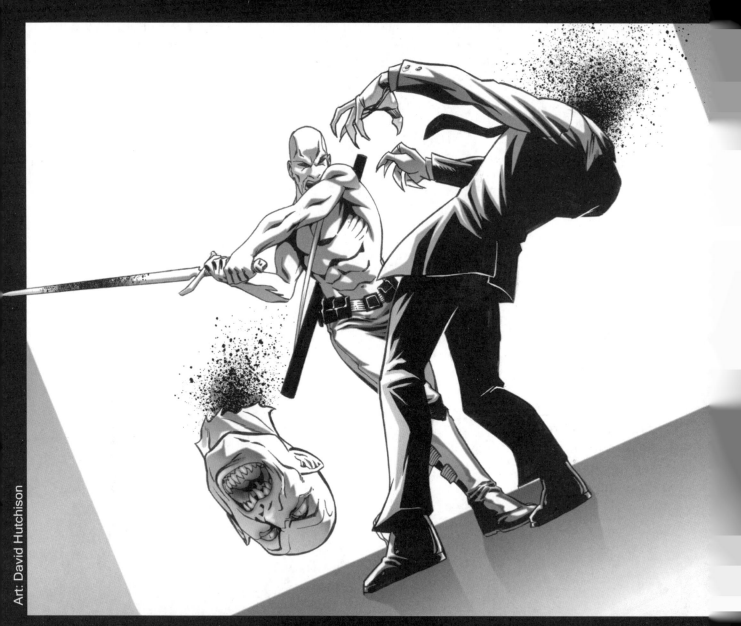

Art: David Hutchison

Well, it's not a clean cut now that I've added a blood-spurt from the wound. This can be done easily with a toothbrush or watercolor brush dipped in ink and then flicked in the direction you want the blood to spray.

FIRE

Art: Ben Dunn

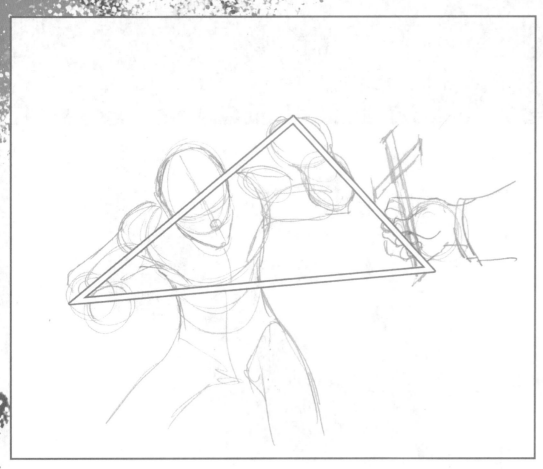

In starting off this drawing, I'm trying to keep my composition in mind. There are a lot of elements on the page. I want to get all of the information across, and there needs to be a clear flow to the work.

The hands really come into play, helping to complement the anger and pain playing across the face of the vampire.

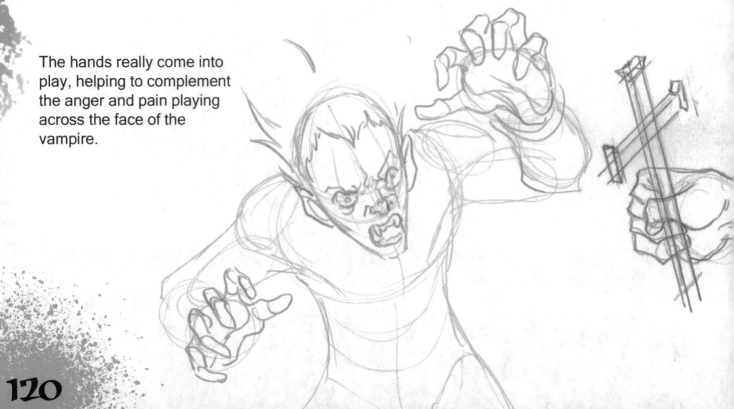

A lot of study could be devoted to the mechanics of fire and how to depict it. I just want a nice, solid flame, without getting too involved. Make sure that the flames feel alive; if the linework on the fire is too uniform, it will seem static and dead, not dangerous or exciting to look at.

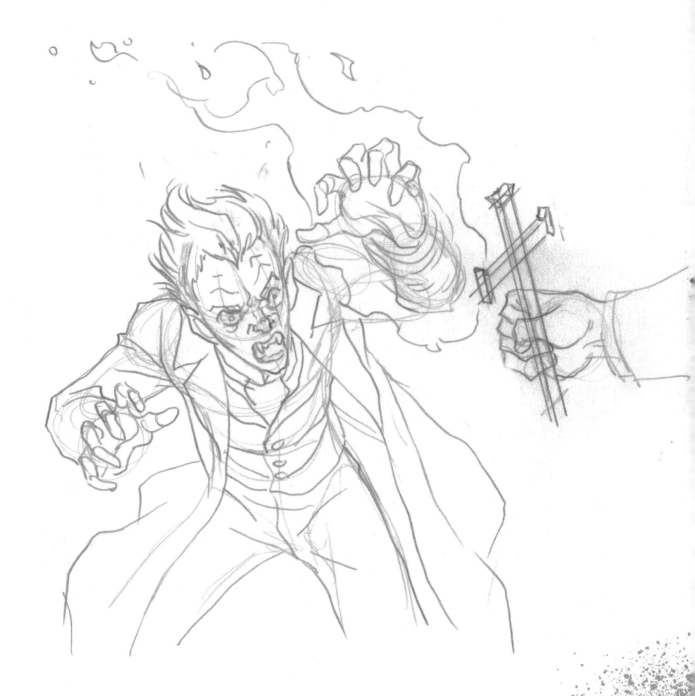

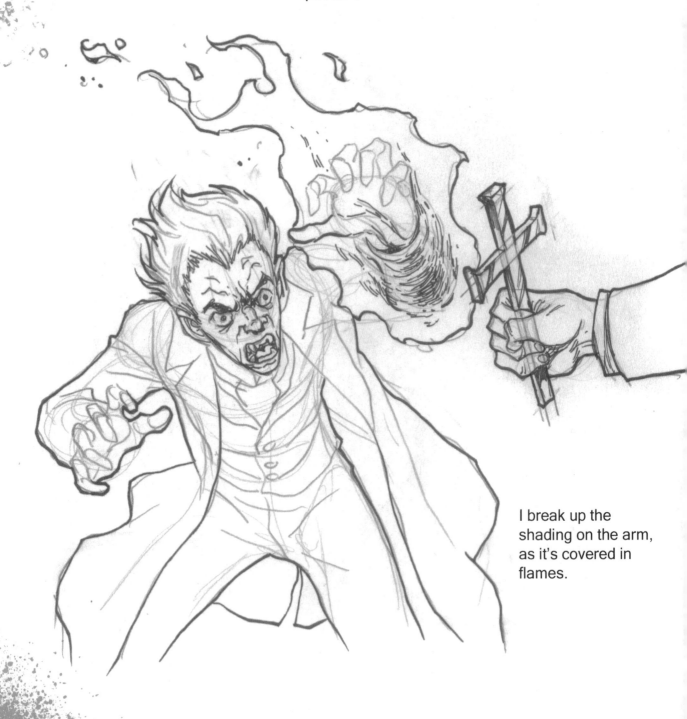

I keep these thoughts in mind as I begin inking the drawing. I give the flame as much variation and alternate the line width as much as possible.

I break up the shading on the arm, as it's covered in flames.

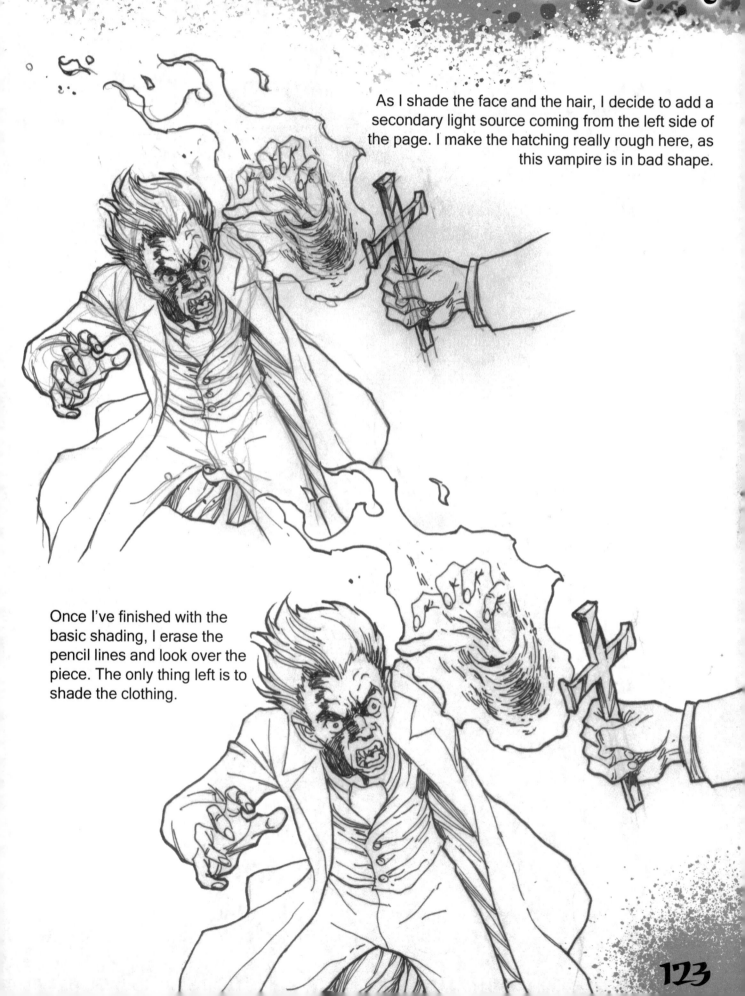

As I shade the face and the hair, I decide to add a secondary light source coming from the left side of the page. I make the hatching really rough here, as this vampire is in bad shape.

Once I've finished with the basic shading, I erase the pencil lines and look over the piece. The only thing left is to shade the clothing.

Things look bad for our vampire. This is almost a no-win situation. The fire will keep burning until there is nothing but ash. This doesn't necessarily mean the end of a vampire, as a few drops of blood mixed into the ash will revive even the crispiest count.

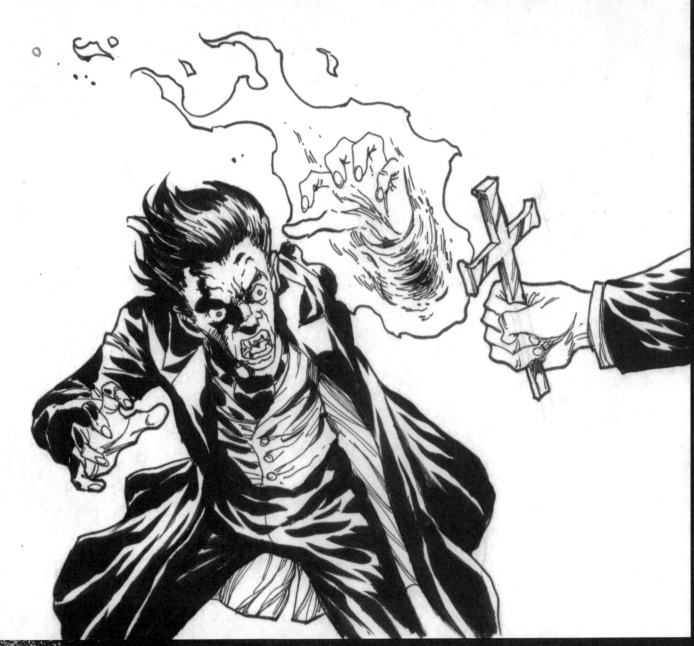

Art: Ben Dunn

Sunlight

Art: Ben Dunn

Ah, sunlight, the great equalizer. Some vampires burst into flame and collapse into a pile of ash after a few seconds in the Sun. There are other types of vampire who, due to their nature or their supernatural strength, aren't affected by sunlight, but they still have good reason to fear it!

No vampire is a match for a human in broad daylight. It saps their strength, robs them of their powers, and gives them a horrible sunburn.

For this piece, I want the Sun to be the focal point. I mark the center point of the Sun and draw a series of converging lines radiating from that point.

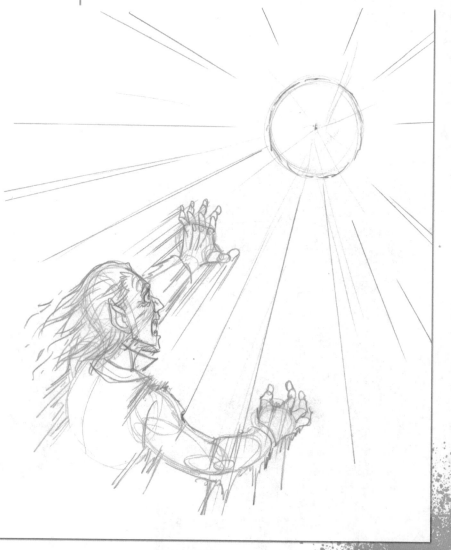

Now to begin the inking process. I break up the outline of the Sun to show the intensity of the light.

I use a different technique to break up the form of the vampire. I want to show just how severely the sunlight is affecting him.

I add a series of hatch marks to the vampire's outline, following the direction of the sunlight.

Since the vampire is close to the camera and getting cooked, I'm going to give him a strong core shadow in solid black.

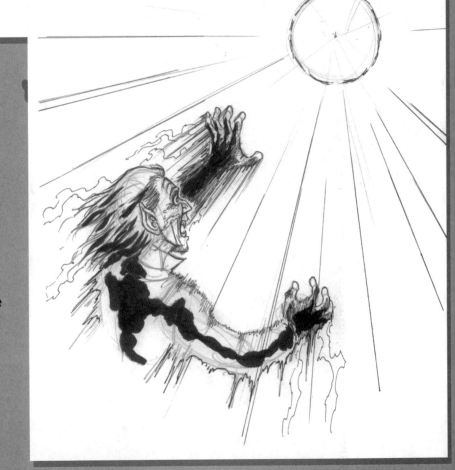

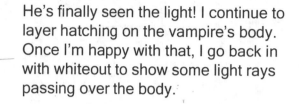

He's finally seen the light! I continue to layer hatching on the vampire's body. Once I'm happy with that, I go back in with whiteout to show some light rays passing over the body.

All of this, coupled with the smoke trails coming off of the body, makes the effect far more convincing.

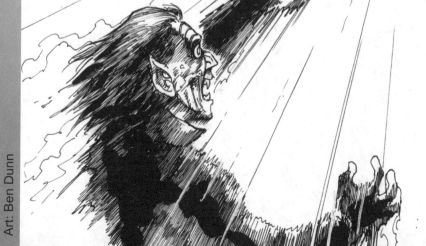

Art: Ben Dunn

Well, we've managed to cover a lot of ground in this volume, but by no means have we addressed everything. Perhaps we'll meet again to learn to draw much more of the ever-expanding vampire mythos.

In the meantime, we hope this text has given you the inspiration to take your first steps into this dark and wonderful dimension. Books, television, and film can help you build on your knowledge of the subject and give you the spark you need to try your own unique take on these creatures of legend and their foes.

So until next time, try to enjoy the daylight.